ELEMENTS OF PAINTING SERIES

# ENLIVEN
# *Your* PAINTINGS *With*
# LIGHT

## PHIL METZGER

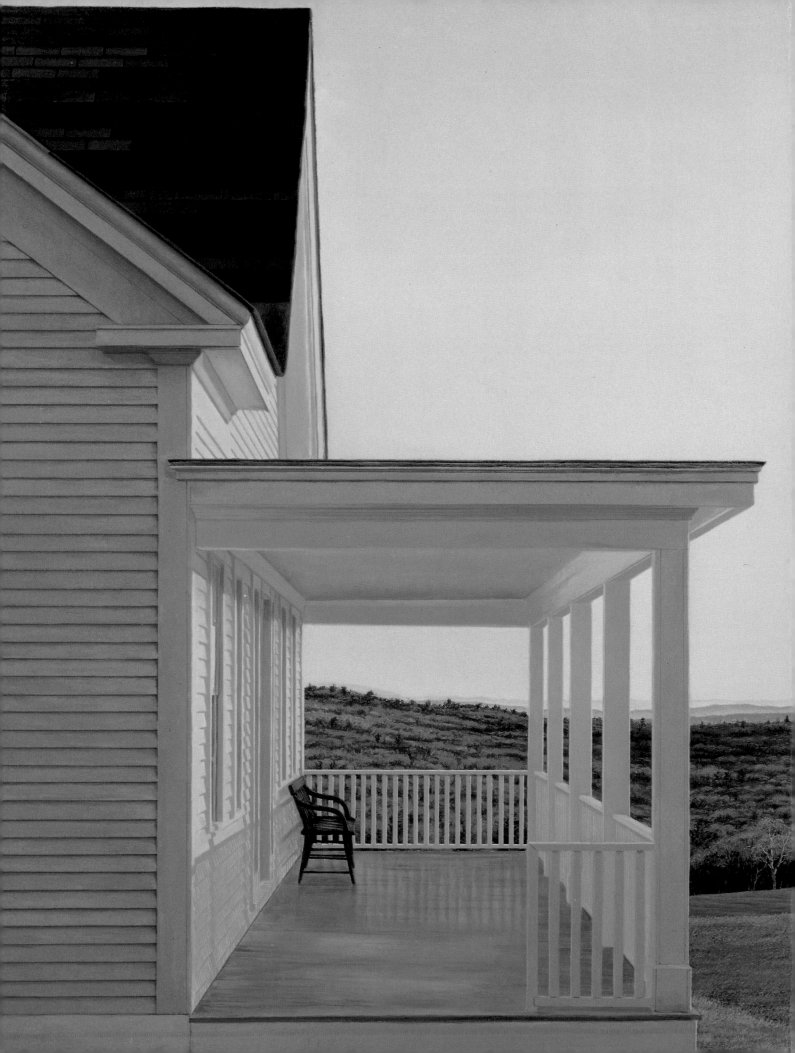

ELEMENTS OF PAINTING SERIES

# ENLIVEN *Your* PAINTINGS *With* LIGHT

## PHIL METZGER

NORTH LIGHT BOOKS
CINCINNATI, OHIO

# About the Author

Without benefit of any formal art training, Phil Metzger left a fifteen-year career in computer programming and management to become a painter. For twenty years he has exhibited his paintings in national and regional shows and has sold his work occasionally through galleries, but mostly at street art fairs. During that time he developed a parallel interest in writing. Having made a number of firm decisions to do one or the other — paint or write — he has now made a firm decision to do both.

Metzger's first success in writing was a 1973 book called *Managing a Programming Project*, still a popular text. That was followed by *Managing a Programming People*, and then two art books, *Perspective Without Pain* and *How to Master Pencil Drawing*. He has also written articles on drawing for *The Artist's Magazine* and *Arts and Activities Magazine*.

This hardcover edition of *Enliven Your Paintings With Light* features a "self-jacket" that eliminates the need for a separate dust jacket. It provides sturdy protection for your book while it saves paper, trees and energy.

Other fine North Light Books are available from your local bookstore, art supply store or direct from the publisher.

97  96  95    5  4  3  2

**Library of Congress Cataloging-in-Publication Data**

Metzger, Philip W.
    Enliven your paintings with light / by Phil Metzger.
       p.  cm.
    Includes bibliographical references and index.
    ISBN 0-89134-514-0
    1. Light in art. 2. Painting—Technique. I. Title.
ND1484.M48  1993
751.4—dc20                        93-15098
                                    CIP

Edited by Rachel Wolf
Designed by Paul Neff

**(Overleaf)**
**Seven PM**
Edward Gordon
Alkyd on panel
24″ × 28″
Collection of Rory and Shelton Zuckerman.

| METRIC CONVERSION CHART | | |
|---|---|---|
| **TO CONVERT** | **TO** | **MULTIPLY BY** |
| Inches | Centimeters | 2.54 |
| Centimeters | Inches | 0.4 |

# Acknowledgments

This is the first book I've undertaken that depended so much on the efforts of others. All the artists shown in these pages had better things to do, after all. Some were so busy traveling the art fair circuit, where they sell their paintings, that they had a tough time squeezing in what I needed. A couple were busy working on their own books, but lent a hand anyway. Some managed to steal time from busy painting and teaching schedules. One even came out of hibernation up on Monhegan Island to help out. Thank you all so very much!

It's traditional to thank the people at the publisher's house for their help in getting out a book— after all, without them there would be no book. (Also, if they are not thanked, they may put a freeze on your royalties!) But I swear there's something in the drinking water at North Light that makes everyone cheerful and helpful and enthusiastic! It's been a delight working with everyone there: Greg Albert and Rachel Wolf, who were with me from the beginning and offered just the right amount of guidance; and Kathy Kipp, Bob Beckstead and Paul Neff, who came in at later stages of the book and did their jobs so well. Thank you all.

I also had help from the Capricorn Gallery in Bethesda, Maryland. The owner, Phil Desind, and his staff helped me locate several artists whose work is exhibited at Capricorn, and I am grateful for their assistance.

There is a little photo store in my town run by Fred Kaplan. Over the years Fred has been a dependable source of (a) advice on photographing artwork, and (b) bad jokes. He also pointed me toward two photo experts, Mike Jones and Francis Knab, who made faithful copies of many of the slides and transparencies sent me by contributors to this book. Fred, Mike, Francis—thank you.

And finally, there was someone who not only contributed art, but also was an enormous help in tracking down other contributors and in reading, correcting and commenting on my writing.

With warm thanks, I dedicate this book to
*Shirley Porter*

# Contents

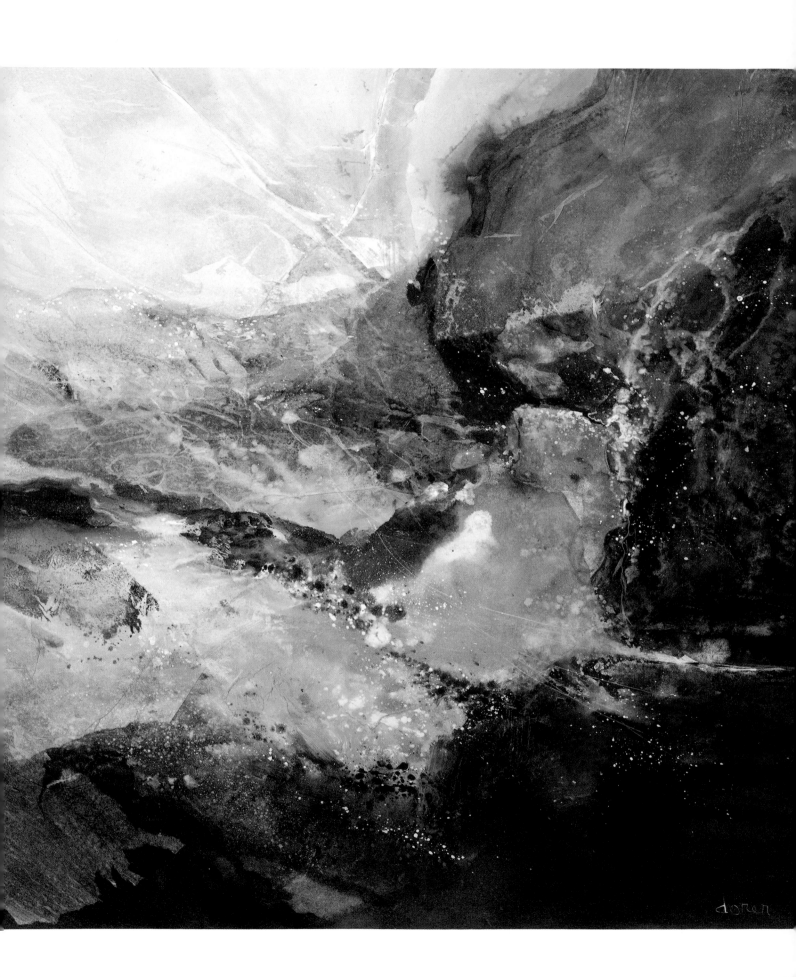

doran

# Introduction

**Ice Flow**
Jan Dorer
Watercolor, acrylic
and rice paper on
matboard
18″ × 18″

Using many washes
and layers of water-
color and acrylic, and
some Japanese rice
paper, Dorer recalls
the brilliance and
beauty of light in
Alaska.

This book is about light: how to see it and how to paint it. Light is not only the energy that drives our lives—there would be no life without it—it's also the energy that defines our art. There would be no art without it.

In the pages that follow we'll deal with light in its practical aspects, concentrating on what the artist needs to know and avoiding unnecessary scientific jargon. This is a book about using light in your art, not about a particular painting medium or a particular painting genre. You'll find a rich variety of illustrations covering many media—oil, acrylic, egg tempera, pastel, watercolor, graphite—and subjects ranging from still life to portraiture to wildlife to landscape.

Something else you'll find here is a group of artists who are anything but purists and who understand that all techniques (other than stealing someone else's work) are fair game. Some paint images projected from slides, one paints with rubber stamps, another dabs on paint with a wad of newspaper, and still another paints in the dark! They all feel, as I do, that what counts is the destination, not how you get there.

This book approaches light from two viewpoints. The first four chapters deal with the *nature* of light—what it is and how it affects the way we see things. We'll begin with the basics of color and value, which together are the foundation on which any painting rests. Then we'll consider a variety of sources of light, one of which is neither sun nor lamp, but the painter's imagination. Next we'll look at the impact of shadows in a composition, and finally we'll study the uses of those lovely bits of errant light, reflections and refractions.

The last four chapters discuss the *role* of light—how it can affect an artist's attempts at creating various illusions in a picture. Choosing the right light can help signal the time of day or the season of the year. It can suggest locale, define distance, illuminate form and texture. Perhaps most intriguing of all, light can help establish the mood of a painting.

Whatever your level of achievement as an artist, whether beginner, professional or somewhere in between, you'll find here practical help without rigid rules and formulas. You'll learn how to observe the effects of light on everything around you and then how to mimic those effects in paint.

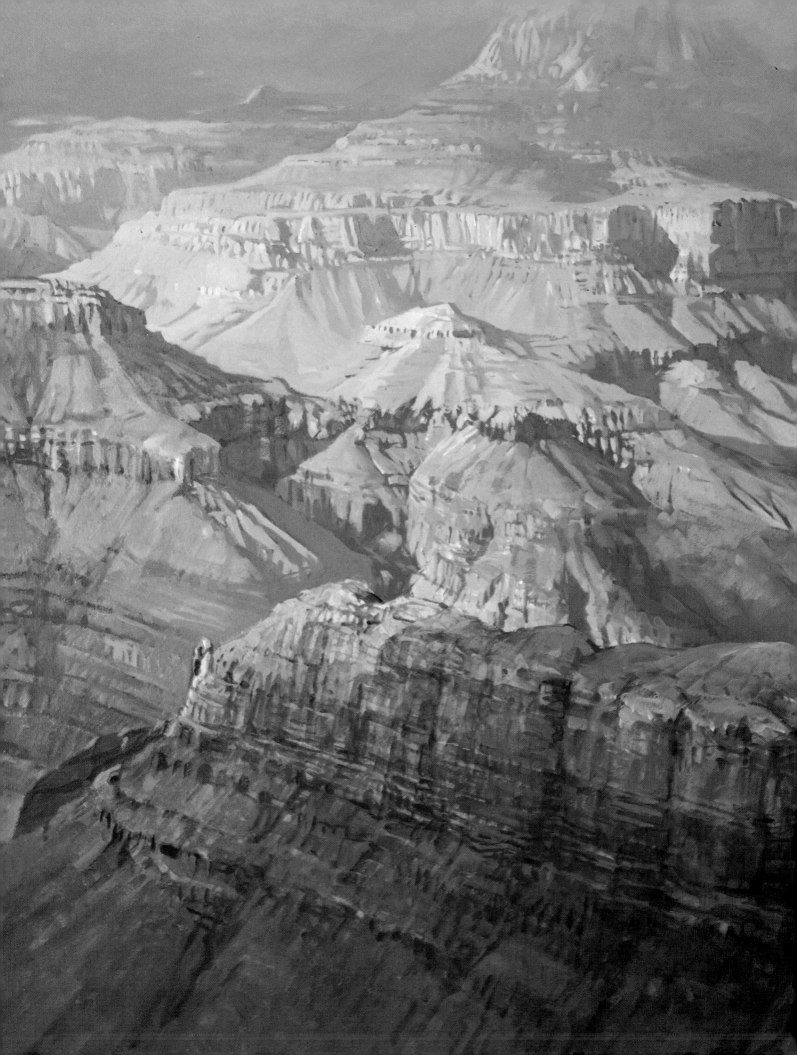

# THE NATURE OF LIGHT

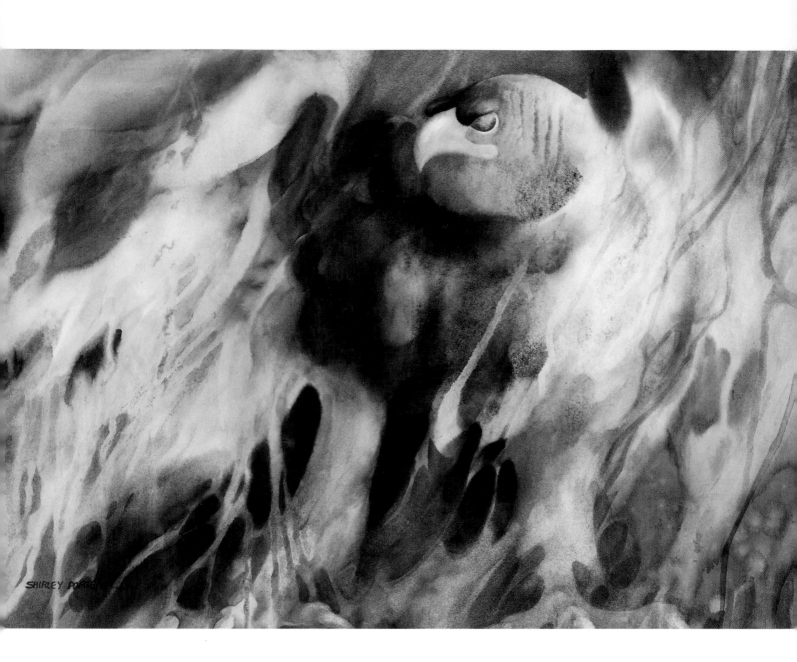

# Chapter One

# The Properties of Light

**Old Soldier**
Shirley Porter
Watercolor
19″ × 26½″

All the grays are mixes of complementary colors, using combinations of alizarin crimson, raw sienna and Winsor blue.

We'll begin by looking at the two properties of light that attract and beguile every painter: color and value. There are paintings and drawings in which color is critical but value is not, and some in which the reverse is true. But in most pictures, *both* color and value are main players. They usually work together to give each picture its punch.

It's hard for us to imagine a time when color and value were not well understood, but it took centuries for artists and scientists to develop the color wheel that we now take for granted, and the idea of modeling forms in shades of light and dark that we now call values. It was not even understood that all colors are contained in "white" light until Sir Isaac Newton made that discovery. Along the way, people like Leonardo, Goethe and Voltaire got into the act, often with a great deal of acrimonious debate.

What's important for today's artist is to have a solid understanding of the basics already established by our predecessors, and to build on those basics with all the invention we can muster.

**(Overleaf)**
**Storm—Lipan Point**
Peter G. Holbrook
Oil and acrylic on paper
26″ × 40″

## Primary and Secondary Colors

The color circle is a device for representing the relationships of pigment colors to one another. Around the circle, red, blue and yellow are placed at equal distances from one another. Those three colors are called *primary* colors; theoretically, all other colors except white can be mixed using combinations of the primaries. I say "theoretically" because, depending on *which* red and *which* blue and *which* yellow you choose, you'll get variations when you mix them. For example, Winsor blue and cadmium yellow will yield greens different from those obtained by mixing cobalt blue and cadmium yellow. What's important is that whatever set of red, yellow and blue pigments you choose as primaries, you can count on consistent results when you mix them.

Between the primaries on the color circle are orange, green and purple, the so-called *secondary* colors that result from the mixing of pairs of primaries. As you can see, an infinite number of color gradations are possible as you travel around the circle.

## Complementary Colors

The color circle shows more than what adjacent colors to mix to get particular results; it's also a guide to mixing beautiful grays. Mix any primary with the secondary color opposite it on the circle and you'll get a gray; vary the proportions of the primary and secondary colors and you'll get a wide range of grays. Such opposite pairs are called *complementary* colors. Red and green are complementary, as are yellow and purple or orange and blue. Although you can mix black and white to get gray, an exciting variety of grays can be had simply by mixing complements.

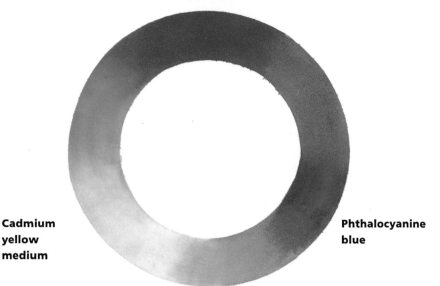

**Deep brilliant red**

**Cadmium yellow medium**

**Phthalocyanine blue**

A simple color circle shows the three primaries—red, yellow and blue, with three secondary colors—orange, green and purple.

**Primary colors**

**Secondary colors**

The middle area of each bar shows some of the grays that result from mixing a primary color and its complement.

# Different Kinds of Primaries

If white light contains all colors, why can't white paint be made by mixing all the colors? The reason is that when mixed, colored *pigments* react differently than colored *lights*. If you mix red and green *paints*, for example, you get a range of browns and grays; but if you mix red and green *lights*, you get yellow!

Those two worlds—that of pigment and that of light—have their own sets of primary colors. When painters speak of primary colors, they mean red, yellow and blue, which mix in the predictable manner illustrated by the color wheel. When physicists and engineers speak of primary colors, they mean red, blue and green. From those three light colors, all others (including white) can be produced.

Besides the endless range of possibilities available using complementary grays, complementary mixing allows you to choose grays that are compatible with the rest of the painting. Color harmony is easier to achieve if you mix your grays from the pigments you're using. In *Old Soldier* (page 4), Shirley Porter used many grays, all mixed from the primary colors used in the painting: alizarin crimson, Winsor blue and raw sienna.

Another aspect of complementary colors can aid in achieving vibrant light effects. Complementaries next to each other tend to enhance each other. For example, placing blue and orange side by side makes the blue seem bluer and the orange more orange than they appear when viewed separately.

In *The Winners* and in *Stone Barn II* (right), Sally Strand and Michael Brown skillfully arrange complementary colors for stimulating interplay. Notice that complementary colors need not be "pure" orange and blue (or yellow and purple, or red and green) in order to enhance one another. A skin tone or background that's roughly orange, for example, works beautifully against a bluish shirt sleeve.

## Hue and Intensity

The word "color" is a broad term that usually doesn't need elaboration, but sometimes it's necessary to separate out two of its components, hue and intensity. *Hue* refers to the names we give specific colors—e.g., red, blue, yellow and green are hues. For each family of hues there are strong and weak members, and the term often used to refer to this quality is *intensity*. Within the family of reds, for example, there are brilliant members said to have high intensity and duller reds of low intensity.

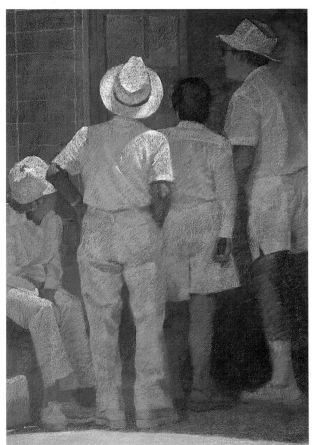

**The Winners**
Sally Strand
Pastel on paper
42½″ × 30½″

This scene filled with reflected light is alive with vibrating complementary colors. The orange tone on the background and skin make the blue-toned clothing vibrate and appear to us clearly as white in shadow. The yellowish white of the hat sets it apart as being in direct sunlight. Strand often paints such complementaries even when they are missing from the actual scene she is painting.

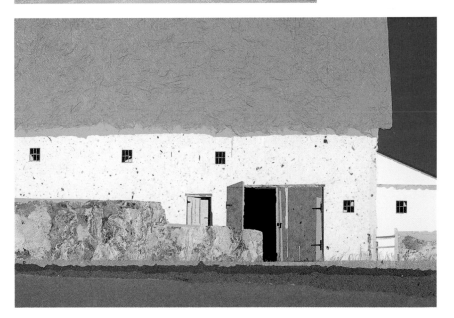

**Stone Barn II**
Michael David Brown
Paperwork
32″ × 40″

In this collage, Brown achieves an intense feeling of light by placing simple blocks and strips of complementary colors next to one another. The yellow side of the barn adjoins a purple strip of ground and a deep purple sky.

## Your Color Palette

Achieving light effects by the use of color is not a matter of doggedly following some set of rules. The color wheel directs the painter in making basic decisions about choosing and mixing pigments, but in the end, color is a subjective experience. Everyone *sees* color differently. Probably no two people perceive the same color when looking at a given object.

When you began painting, perhaps you bought your first set of colors to match those used by some admired artist. My first colors were those used by John Pike, who got me started in watercolor. I used his set of colors (French ultramarine blue, Thalo blue, Thalo green, alizarin crimson, cadmium red light, new gamboge yellow, cadmium yellow, burnt sienna and burnt umber) for a long time. Gradually I added others, such as yellow ochre, raw sienna, raw umber and cobalt blue, and I continue to experiment with still others.

In theory, you could lay out a palette using only a standard red, a standard blue and a standard yellow if you're working in watercolor, and add a white if you're working in an opaque medium. Again in theory, those three or four colors should allow you to mix any color you want, including any gray. But for several reasons the world of pigments is not quite that orderly.

First, there is no such thing as a "standard" red or blue or yellow. Instead, there is a wide range of basic colors that all react differently when mixed with one another. For example cadmium red, when mixed with any given blue, will yield purples strikingly different from those you get by mixing alizarin crimson with that same blue.

Second, each primary color is really a family of colors having both "warm" and "cool" members. For instance, phthalocyanine blue has an icy (cool) look, or "temperature," compared with ultramarine blue, which has a reddish (warm) temperature, so phthalo blue is called a cool blue and ultramarine, a warm blue. It's all relative; *both* blues are cool compared to any red. Similarly, there are warm and cool reds and warm and cool yellows.

Third, although every pair of colors mixes in a predictable manner, not all the results are suitable. Some pairs of complements, for example, yield grays that look like sludge. Like some people, certain pigments don't behave well when mixed. The only way to find out what the various pigments will do for you is to try them.

After a time, you settle down with a set of pigments you like. But you can get so comfortable with your palette that you get in a rut; all your paintings begin to look alike. There's no law against that, but if you don't experiment you don't grow. Try some departures from your usual palette. You can go radical and adopt a completely new set of pigments or make more cautious changes, such as doing without one or two favorite colors. The first time I tried painting without my beloved earth colors I felt paralyzed, but I've found that forcing change in painting always opens up brand-new possibilities.

# Wet/Dry Pastel Techniques on a Sanded Board

Here are the techniques and materials Barbara Hails used in her demonstration painting *Rose Gate* (page 10), as well as in many of her other paintings.

*The painting surface:* Hails uses acid-free, four-ply museum rag matboard. To condition it to receive both wet and dry stages of the painting, she applies a thin coat of ground "glass" (e.g., 200-mesh flint, pumice, marble dust or Carborundum) in acrylic gel medium to the front. To equalize the tension, she also applies a light coat of diluted acrylic gesso to the back.

*The drawing:* Because the soft nature of pastel naturally diffuses edges, it's necessary to establish accurately any rigid structures, such as buildings or trellises, before painting. Most often, Hails uses a very sharp no. 2 pencil with ruler and T square. Because it's difficult to cover pencil lead with pastel chalk, she switches to non-photo blue pencil in areas where regular pencil might cause a problem later. She does little or no drawing for organic forms.

*Acrylic underpainting:* Pastel appears brighter and richer when contrasted with a dark or dull-colored surface, so Hails paints the basic colors with darker, muted, thin acrylic, which she allows to dry before applying any chalk. She usually underpaints the entire board, except where some bright white is to be left as part of the final painting. She does the underpainting carefully, as can be seen in *Rose Gate*, and must be fully satisfied before proceeding to chalk.

*Applying the pastel:* When applying pastel to an underpainted sanded board, sequences are critical. In layering, dark pastel precedes light pastel to avoid muddy color. Paint the background before the foreground, and general forms before details. To keep the color fresh, Hails does no blending with fingers, tissues, or the like.

*Finish:* Hails shakes the completed painting well to remove loose pastel dust, then mats and frames it under glass. She does not use fixative.

## Demonstration ▪ Barbara Hails
# Underpainting With Color

Artists use many techniques for suggesting light. Hails uses one of the most effective, underpainting first in colors that are complements or near-complements to the final colors. Broken pastel strokes allow bits of underpainting to show through, and the result is a double whammy: Broken strokes have their own vibrancy, but when placed over complementary colors, the effect is further enhanced.

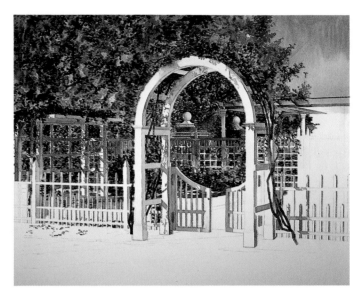

**Rose Gate**
Barbara Hails
Pastel on ground glass board
24″ × 30″

### Step 1
Hails draws the garden structures carefully, using regular lead and non-photo blue pencils. In looser areas, such as foliage and flowers, she does little or no pencil drawing. She has begun to block in with acrylic paint all areas except those to be left white. The sky area is painted with a pale wash of cadmium red and alizarin that will show through and vibrate against a later application of complementary blue pastel.

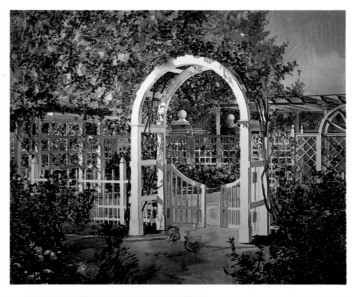

### Step 2
With the acrylic underpainting nearly finished, Hails critiques the composition carefully and decides the foreground is too empty. She uses charcoal to test additional shrubbery and some birds, and when satisfied, begins painting the additions in acrylic.

### Step 3
To enhance the feeling of sunlight, Hails deepens the foreground shadows and adds the last of the rosebushes, which are primarily in shadow. These darks will make the light seem more brilliant. She paints the doves with pale, transparent blue, still using acrylic.

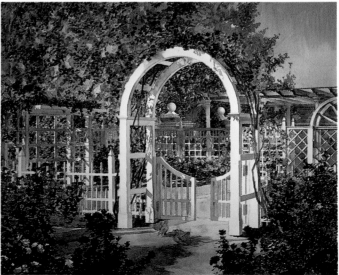

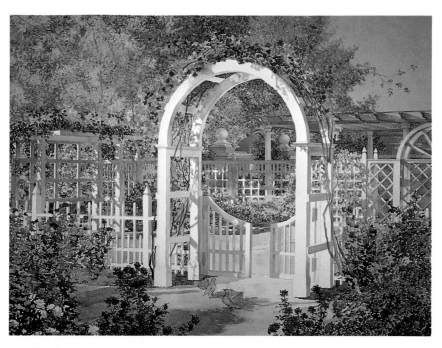

**Step 4**
Only now is pastel applied. Hails paints the background first. She brings the sky and distant foliage almost to completion, both in cool colors. To create an illusion of sunlight in the painting, she gives the trees to the left (nearer the light source) a yellow cast, while giving the distant sky on the right a darker and redder blue toward the top and right edges of the picture.

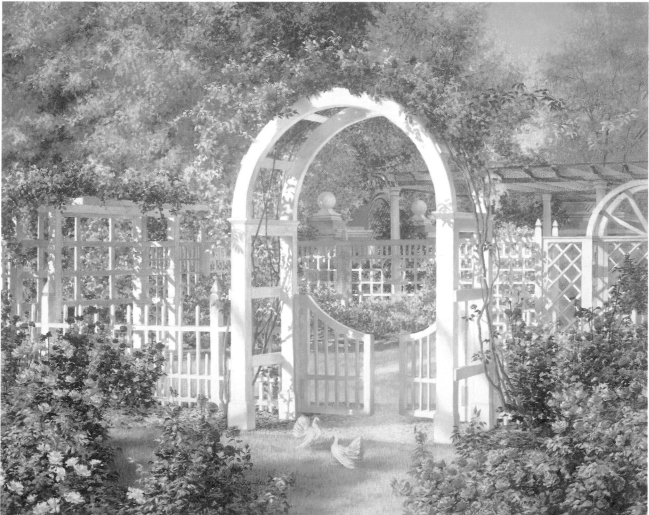

**Step 5**
She paints the middle ground with pastel next, and finally the foreground. Shadows on the woodwork are filled with color and value variation. (Shadows are darkest near their origin. As a shadow moves away from the object casting it, reflected light invades, changing its color and lightening its value.) Surrounding yellows and pinks reflect into the left-hand structure, warming its face. Hails adds sunny highlights all over flowers and foliage. Finally, she refines the foreground grasses and makes cast ground shadows bluer and softer. She softens some edges and corrects a few values.

## Seeing and Expressing Values

The relative lightness or darkness of an area is called its *value*. The darkest, or lowest, value is black; the lightest, or highest, is white.

The idea of value applies to areas of color as well as to areas of white, gray and black—the values of colored areas are evident when they are photographed on black-and-white film. If you carefully place areas of contrasting values you can build just the mood you want, and combining strong value contrasts with striking color arrangements can yield dynamic results.

In *Stone Barn II* (page 7), strong value contrasts force you to take notice. If you cover the dark upper right sky area and the dark open doorway with pieces of paper of the same general colors but of much lighter value, the painting loses a lot of its punch. Furthermore, the entire middle third of the painting is light, bounded by a dark upper strip and a dark lower strip; this arrangement of values makes the center strip appear vibrantly light.

When you're looking for places in your painting where you can logically deepen and lighten some values, seek clues in your subject. As in Michael Brown's barn, for example, there may be doors or windows that you can exploit. If they don't fall where you'd like them to, feel free to move them around in your picture.

There's no reason to stick literally to what you see unless you're doing a portrait. Look at the subject for ideas and then improvise. If there are no obvious excuses in the subject for introducing value contrasts, then invent some. I'll guarantee you, the barn Brown used as the subject of his painting was quite different from the one we see in his final version.

# Value-ing a Scene

You can change the mood and impact of any scene by playing with the values. Sometimes this means imagining the light source in different positions, as shown here. But values do not have to be tied to a literal light source. You are at liberty to alter them at will, provided only that the result enhances the picture's effectiveness

(a) The sun is lighting all visible surfaces fairly equally:

(b) Shifting the sun left throws the right side into shadow and gives the barn depth:

(c) The barn is arbitrarily made darker so that it stands out from the background:

(d) Values are reversed.

## Theory of Relativity

Careful observation of values in your painting subjects will yield sometimes surprising results. Wherever light is involved, illusions are common. On page 13 (top), for example, wouldn't you bet a dollar that the tree on the left is darker than the tree on the right?

It's not, of course—both are exactly the same value, cut from the same piece of gray matboard. The theory of relativity (mine, not Einstein's) is at work. Objects take on a different look depending on what is around them. A white sea gull seen against a brilliant sky may appear dark; the same bird against a dark rock or the blue ocean will appear white. Look at this series of squares on page 13 (center). They are all the same value, but *relative to the background* they appear to get lighter from left to right.

Such illusions are common in nature. If you're doing a more or less representational (as opposed to abstract or nonobjective) painting, observe these illusions and include them in your work. Suppose, for example, you're painting "white" birches whose lower parts are seen against a dark background

and whose upper sections are backed by a brilliant sky. Although the trees are fairly uniform in color and value, the lower parts seem very light compared to the dark background, and the upper parts appear dark gray or black against the bright sky. Watch for similar situations around you and you can see for yourself how common this illusion is. Even a darker object such as a telephone pole or a gray tree trunk seen under these conditions may give the same illusion, although perhaps not in such a dramatic fashion.

There's nothing new about this notion, of course. Leonardo da Vinci wrote: "Of different bodies equal in whiteness . . . that which is surrounded by the greatest darkness will appear the whitest; and on the contrary, that shadow will appear the darkest which has the brightest white round it."

You're often confronted with a conflict between what you *know* (the entire birch tree is white) and what you *see* (the top of the tree looks dark, the bottom looks light). If you're going for realism, then paint what you see; include in your picture the same illusions that occur when you view the actual subject. But if you're painting abstractly, anything goes. In *Sandy Sequence* (right, bottom), Alex Powers draws us in by using powerful value contrasts along with effective division of the picture area. He applies conventional lighting to the center head, but in the rest of the painting he places dark paint and spare line just where needed to provide the impact he wants, and to hell with realism!

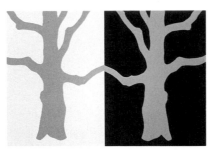

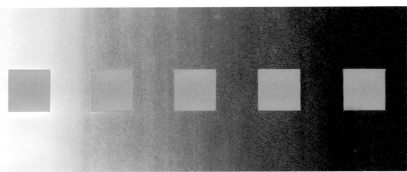

Although the two tree shapes are cut from the same piece of matboard, the one on the left *appears* darker because we see it *relative* to the bright background. How we see an object is strongly influenced by what is around it.

All the squares are the same value, but they appear progressively lighter as they become surrounded by increasingly darker values.

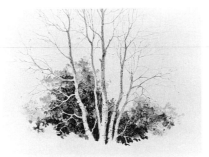

Very close up, these birches are uniformly white; from a little distance, they appear white only where the background is dark. Where the background is bright, the "white" birches appear gray. If you are painting realism, you sometimes need to ignore what you *know* and paint what you *see*, illusions and all!

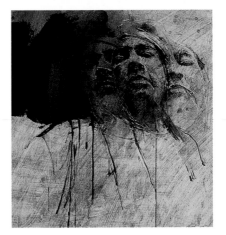

**Sandy Sequence**
Alex Powers
Watercolor, charcoal and pastel
20″ × 19″

Powers chooses to use a single light source to model the center head, but abandons tradition in the rest of the painting. He uses striking value contrasts to force you to focus on the heads. There is no modeling in the shoulders—they remain a flat space with only a few well-placed lines to suggest form without taking attention away from the heads.

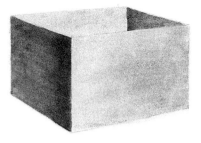

### Values at Edges

Where two areas of contrasting values meet, the difference between the values will seem more pronounced closest to the edge. These box surfaces (right, top) might represent adjoining walls of a house. One wall is in direct sunlight and the other in shadow. The lighted wall seems brightest, and the darker wall darkest, where they meet. This is another example of relativity at work: The closeness of the dark makes the light seem lighter, and the closeness of the light makes the dark seem darker. Although I have exaggerated the effect in this sketch, you'll find that the more you study objects in nature, the more you'll notice this phenomenon.

### Spotlighting

By arranging values properly you can force the viewer to focus on your center of interest. In many portraits and still lifes the subject is painted in relatively light values but is surrounded by huge areas of dark, as if caught in a spotlight. *Blue Mood* (below) is a nature study using the spotlighting idea. Essentially, this is a two-value painting. The surrounding darks

Another illusion—near the meeting of two areas of differing values, each influences the other. At the edge, the dark will seem darker and the light will seem lighter.

practically force your eye to the lighted areas. Don't go overboard. If you surround your subject completely with darks, it may end up looking like a bull's-eye. Let the lighted center of interest connect to the edges so that the subject does not seem to float.

**Blue Mood**
Phil Metzger
Watercolor and acrylic on illustration board
30″ × 40″

This is one of a series of paintings in which I focused on some little corner of the woods. I did so by spotlighting the center of interest, which means lighting the subject and surrounding it with dark. To make the spotlighting less obvious I let the lighted areas break out at a few places around the edges of the painting.

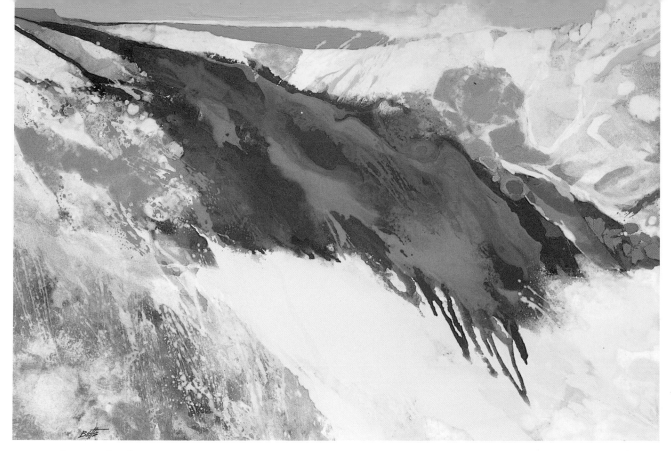

## Negative Painting

Take another look at *Old Soldier* (page 4). This bird looks as though it has survived some tough times with strength and dignity. The pattern of surreal light washing over the bird is made meaningful by contrasting midtones and darks. There are just enough carefully placed darks to emphasize the lights and sculpt the bird without spelling out each feather. The darks and semi-darks are examples of negative painting.

Negative painting means expressing an object by painting the area *around* the object, like a sculptor carving away excess clay or stone. Essentially, you first paint everything light and then watch the form pop out as you carve away with your darks. Here, the darks that define the bird's legs are examples of negative painting.

## Color Without Value

Before Impressionists came on the scene in the late nineteenth century, *value* was seen as an indispensable means of expressing the form and volume of an object. To express the roundness, say, of a human head, painters would paint the head brightest near the source of light, with gradually weakening light (lowering value) on the parts of the head turned away from the light source. Painters of realism still rely on value change.

Many painters, beginning with the Impressionists and continuing to this day, have sought to express form in other ways, one of which is to ignore value change and to let color do all the talking. Paul Cézanne's consuming passion was the realization of form, not in terms of value change, but by means of closely observed and carefully thought-out patches of color placed one against the other.

There is, of course, no "right" way. Artists are free to use color *or* value, or color *and* value, in expressing form; indeed, many artists free themselves from expressing form at all and simply deal with the canvas or the paper, striving to make its surface exciting by any means they can invent.

**Suncoast**
Edward Betts
Acrylic on Masonite
36″ × 48″

This is a painting meant to evoke a warm, sunny landscape effect rather than literally describe a particular location. The colors and shapes merely suggest dunes, beach, ocean, sea-spray, horizon and grasses. Betts has relied on color, not value change, to suggest his subject. "Indeed," he says, "modeling forms in strong light and deep shadows would be totally out of place in a color context of this sort. Color and light are the principal ingredients here, with landscape imagery serving only as a point of departure."

# Chapter Two
# Light Sources

Anyone who has tried to duplicate the brilliance of light in paint knows what frustration is, for light has an energy we can only approximate in paint. Neither the whitest paper nor the most brilliant pigment can equal sunlight or the glow of an electric lamp. To make up for the deficit, we adopt every artifice we can to trick the eye and make our paintings seem what they are not.

The tricks we use have a lot to do with the kind of light we're trying to paint. Sunlight, moonlight, lamplight—all have obvious differences in color and intensity. But there are other differences not so apparent. What causes double shadows, for example, when there seems to be only a single light source? What's the difference between direct and indirect light? How do you handle multiple light sources?

And then there are those who invent their own light. Like Don Quixote, these artists say: "Come! Enter into my imagination. See things as they *really* are!" Fully conversant with traditional light behavior, they turn their eyes inward to find light that suits their needs. But as you'll see, even those who paint imaginary light usually maintain some link with reality.

**White Barn**
Michael David Brown
Watercolor on Arches 300-lb. cold-press
paper
30" × 40"

As in most of his paintings, Brown forgoes
detail and concentrates on simple shapes
and color. The strong blue vibrates against
the white of the barn and foreground to
give an illusion of glaring light.

## Single Light Source

Although the source of light for most landscapes and seascapes is the sun, Don Stone's *Overnight Guests* (page 16) is lit by the sun's surrogate, the moon, supported by the small, flickering lights from lamps scattered among the boats. When painting a moonlight scene, you have only a limited range of values to work with. Get the values too dark and you blot out too much detail; too light, and you destroy the illusion of moonlight. Although Stone's method was to adjust the values by a straightforward mixing of opaque paint, there are other approaches. For instance, you might paint the scene lighter than you envision it in the final painting and then apply successive blue-gray glazes over all or most of the painting until you're satisfied. The method you choose is partly a matter of temperament—the fussiness of glazing might appeal to one painter's methodical bent, but might drive another crazy.

Far from moonlit Maine is Joyce Pike, in sunny California, where she demonstrates a sunlit floral painting (pages 22-23). She places a bouquet of roses on a walkway outside her studio, where the cast shadows seem black in comparison to the bright sunlight. A single, strong light source will always cause dark, sharp shadows if there is not some moderating influence, such as a textured surface or strong reflections into the shadow area. In Pike's demonstration painting, strong shadows are a major design element.

Another way to emphasize the brilliance of a single light source such as sunlight is to employ extremes of value and color, as Michael Brown has done in *White Barn* (above) and Neil Adamson in *Fish Pails and Floats* (page 19, top). These painters chose to play large, simple, light shapes against equally simple, but darker, more colorful shapes. In Brown's case, the barn and foreground are essentially white against an intense blue background, and there is no fussing with unnecessary detail. Adamson decided to leave the background pure white and concentrate all color in the pails and floats. He started the pails with washes of burnt umber, burnt sienna and yellow ochre, and in the next paint layers he used some spatter and sponges to get more form, texture and color. After letting these layers dry, he painted shadows with warm and cool variations, using mixtures of ultramarine blue, burnt umber and burnt sienna. Finally he added titanium white to his color mixes to paint opaque highlights.

Robert Brawley treats light in a wholly different way in *Crucible* (page 19, bottom). His light source is soft, indirect sunlight—we don't know whether the light was softened by some haze or screen, or by his imagination. Not relying on stark contrasts, he instead captures delicate, subtle nuances. "As an artist," says Brawley, "I must consider light and shadow on every level of the work. It is the fundamental structure and logic of the work, underpinning the ordering and sequencing of the painting or drawing from beginning to end." Brawley misses nothing—not the delicate, transparent shadow on the folds of the cloth, not the reflected green along the base of the backdrop, and not the infinite gradations of color and value in every surface.

### Fish Pails and Floats
Neil H. Adamson
Acrylic watercolor on Strathmore 4-ply
plate surface
22" × 30"

Adamson was sure these worn pails and
floats could tell a hundred stories if they
could talk. The wooden dock on which
they sat was bleached almost white,
which made the objects and their shad-
ows striking.

### Crucible
Robert J. Brawley
Alkyd and oil on wood panel
26" × 20"
Collection of Mr. and Mrs. Jerome Kaplan,
Bethesda, Maryland.

"When I saw this crusty succulent, the soft
indirect daylight spilling down over the fat
leaves and the budding flowers reaching
and straining for the light, I knew I wanted
to paint it," Brawley says. "What pleases
me the most about the painting is the lu-
minous, almost transcendental light re-
flected from the tablecloth. The strong
dark textures of the succulent, the pot and
the wall provide the contrast to the ethe-
real quality of the light on the cloth."

Many artists set up still lifes and paint the effects of light on their made-up scenes. Sharon Maczko goes a step further: She constructs theater-like sets, complete with artificial light sources, and paints the results. *The Mind at Play #7* (above) is one of her many invented scenes, recalling boring afternoons as a small child when she, like most children, found ways to keep herself occupied. Maczko constructs a set for each painting she does. This often involves not simply gathering and arranging objects, but *building* things. For one set she built a small window frame and vanity out of wood and a wall out of matboard, and sewed curtains

for her window. Whatever the props, central to her paintings is the placement of one or more light sources to create just the right mood.

**The Mind at Play #7**
Sharon Maczko
Transparent watercolor
23" × 37"
Photo courtesy of Gene Ogami.

"A simple sheet thrown over a chair is an instant fort—a realm of royalty!" Maczko says. "After assembling chairs, cardboard cupboards and oven, and using poster board for linoleum, I suspended a single high-wattage light dead center behind the sheet. The vivid light reflecting off the stove and cupboards creates that familiar kitchen brightness."

## Mending the Nets
Michael P. Rocco
Watercolor
18″ × 24″

Depicting glaring sunlight and deep shadow, Rocco treated this painting in traditional watercolor manner, starting with the distant sky and water and working forward. The deep shadows in the foliage and especially the shadows cloaking much of the faces lend an air of mystery. Everything is painted transparently except the netting, which is rendered using tinted opaque white.

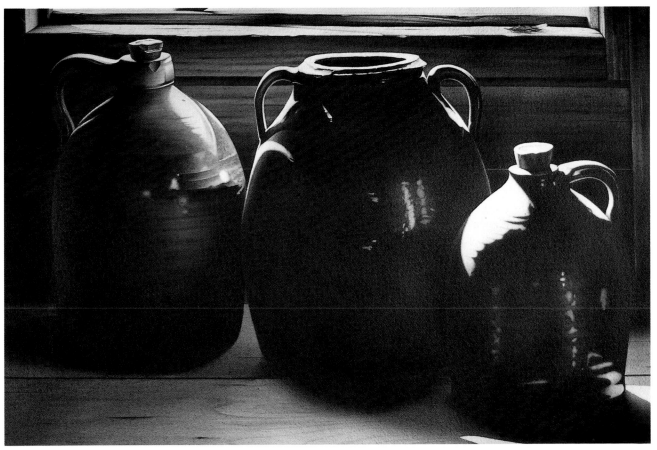

## Three Brown Jugs
Wayne Waldron
Watercolor and acrylic on Arches 300-lb. rough paper
22″ × 30″

Light from a single source, the sun, streams through a window and dramatically highlights these forms. Just enough reflected light is used to model the dark shapes and rescue them from flatness. Waldron works with transparent paint and has mastered the laying down of subtle washes. He patiently glazes (applies washes over previously dried layers) to model the forms. He introduces subtle color variations into an essentially monochromatic painting to capture the dusty jug surfaces. For an extra bit of color he adds the jay feather on the sill.

## Demonstration ■ Joyce Pike
# A Strong Single Light Source

Still lifes are usually arranged indoors under artificial light, but this one is on the sidewalk under intense sunlight. Notice the stark differences in treatment between this demonstration painting and Pike's *White Roses* (page 24). Under a single, strong light source, such as an unclouded sun in California, shadows are deeper in value and edges are sharper than under weaker, more diffused light.

A photo of Pike's subject.

**Study of Light**
Joyce Pike
Oil on canvas
18" × 24"

### Step 1

Pike first paints in quickly the strong color and value pattern of the container of flowers and the cast shadow, modifying what she sees before her for the sake of effective design. Then she mixes a variety of warm and cool grays for the background, using her dominant red-orange color and its complement, green, along with varying amounts of white.

### Step 2

She now paints each flower in a degree of detail appropriate to its position in the design. She also establishes green leaves, some in light, some in shadow.

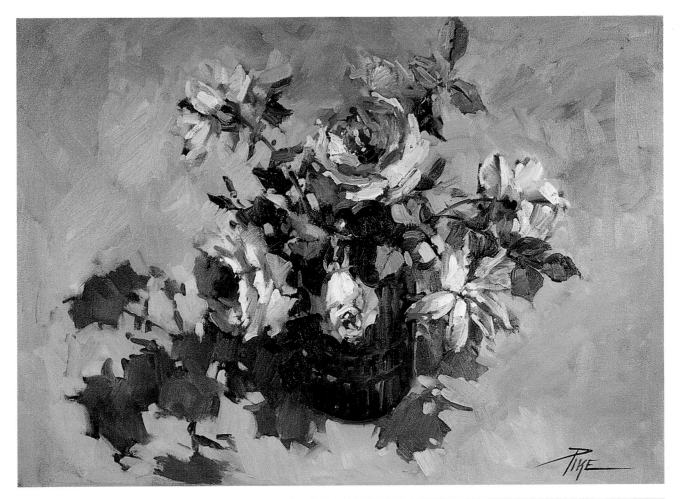

## Step 3

Always design-conscious, Pike adds a bit of cast shadow at the right of the container to strengthen the composition. She softens some flower edges, slightly subdues the background, and modifies color and value in areas where she wants the eye to be drawn.

## Sweet Springs

Joyce Pike
Oil on canvas
18" × 24"

Often the kind of brushstrokes or knife strokes used helps convey an illusion of light. Here, Pike's vigorous, not-too-fussy strokes result in a lively scene. The vertical slashes of light in the trees at the left nicely complement the horizontal light in the water at the right. The lights in the trees work especially well because they are surrounded by relative darks.

## Multiple Light Sources

A single light source generally gives rise to strong, simple shadows, as in Joyce Pike's demonstration. Such situations are often dramatic because of the sharp light/shadow contrasts. Introducing additional light sources usually softens shadows because light from one source invades and weakens shadows caused by light from another source. While the shadows in Pike's demonstration painting are an important part of the overall design, the shadows in *White Roses* (below), with more than one light source, are diffused and of secondary importance.

Depending on the *positions* of the light sources, shadows may cross one another or spread out in opposite directions (more about overlapping shadows in chapter three). If there are enough light sources of sufficient intensity, they may cancel each other's effects and produce almost no shadows at all. In special cases, such as Michael Rocco's *Nostalgia* (page 25), numerous lights create an effect that invites the eye to bounce around the painting rather than focus sharply on any one area. More often, however, artists will use a limited number of sources to focus attention.

**White Roses**
Joyce Pike
Oil on canvas
24″ × 36″

Because the light source is a combination of filtered sunlight and artificial light, the cast shadows here are soft and diffused, making the mood of this painting quieter than that of Pike's *Study of Light* demonstration on pages 22-23.

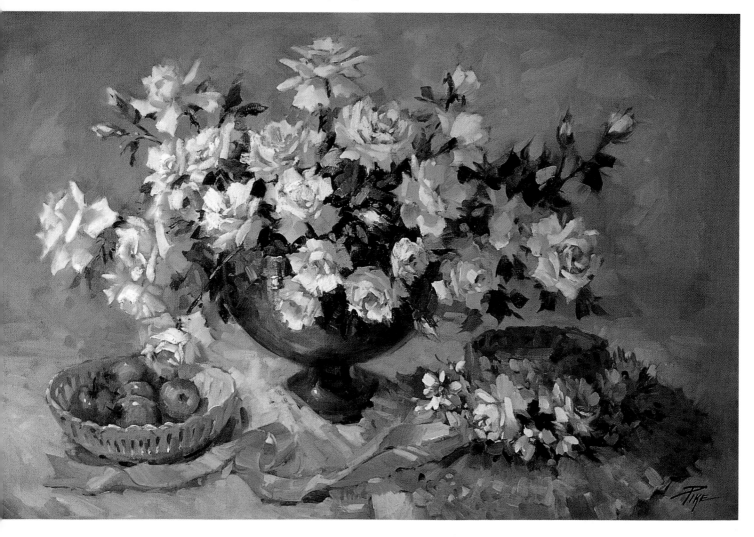

Sometimes a single light source, such as the sun, does double duty and acts as a multiple source. In Sally Strand's demonstration, *Vestibule* (pages 26-27) and in Edward Gordon's *Empty Rooms* (page 28), sunlight is seen entering two or three rooms in a building and playing differently in each room, thus behaving as if from different sources. Such effects arise in a number of ways: (1) Sunlight streaming directly through a south-facing window may show up vividly on floors, walls and furnishings and cause strong shadows. At the same time softer, indirect sunlight reflected from the sky filters through a north window, causing only moderate illumination and vague shadows; (2) sunlight entering through two different windows may have different colors and temperatures—e.g., redder and warmer from the south, bluer and cooler from the north; (3) sunlight entering through one window may arrive unimpeded, while light entering a second window may first pass through some modifying medium, such as tree foliage, or may enter the window only after being reflected from an outside wall. Such engaging effects are likely to be missed if one paints from memory rather than from an actual scene.

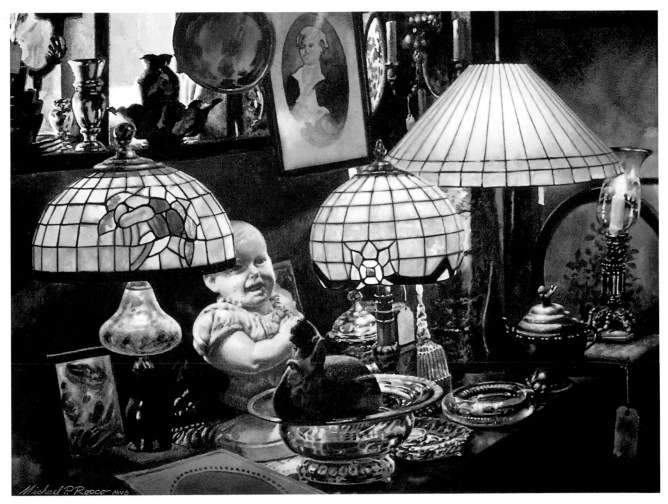

**Nostalgia**
Michael P. Rocco
Watercolor
18" × 24"

Light sources galore! Besides the intrigue of clutter in an antique shop, the multiple light sources made this composition compelling for Rocco because many objects were highlighted, forcing the eye to bounce all over, thus enhancing the feeling of clutter. He began by painting the central area almost to completion, and then moved to other areas, tying everything together with broad areas of dark in the background. The warm light from the lamps provided a nice contrast with the daylight coming through the window at the upper left.

## Demonstration ■ Sally Strand

# Two Light Sources

Multiple light sources give rise to some strange situations. In this scene, the "two" sources were both the sun, but the sunlight entering the far room was direct light and the sunlight entering the near room (the vestibule) was indirect. Windows facing south let in direct light, while windows facing north let in indirect light. Notice that shadows in the far room are cast in one direction, while those in the near room are cast in the opposite direction. Another difference between the two lights is that the direct light is warm, the indirect cool.

**Vestibule**
Sally Strand
Pastel on Arches cold-press watercolor paper
24″ × 30″

**Step 1**
Strand soaks and stretches the watercolor paper and staples it to a wooden board. After doing some preliminary thumbnail sketches to establish the composition, she sketches major shapes directly on the dry watercolor paper using soft vine charcoal.

**Step 2**
She underpaints with acrylic, establishing values and color temperature (warms and cools). The colors are tricky because there are really two light sources.

**Step 3**
She begins applying pastel, feeling her way toward shapes, values and temperature. She adds a chair at the right and a rug at the left to strengthen the composition. She indicates the pattern of light on the floor in the inner room.

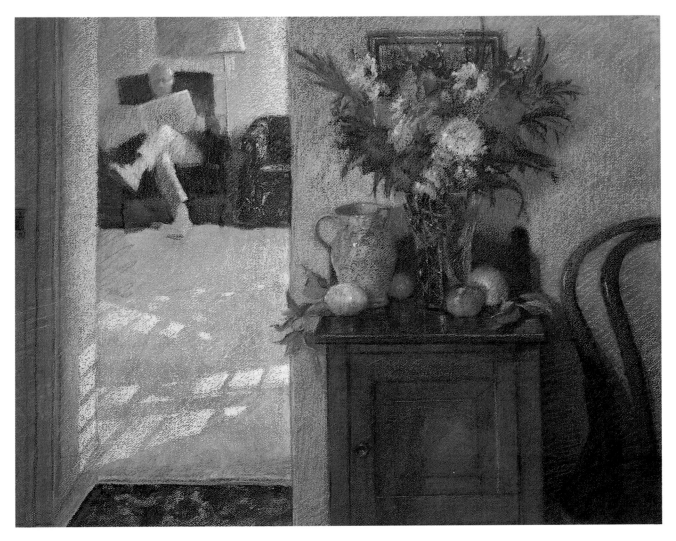

**Step 4**

Strand adds a doorway at the extreme left to make that large vertical strip more interesting, and finishes detailing all the picture elements. The inner room where the man is reading is warmer than the nearer space, a reversal of the usual concept of ''warm colors advancing, cool colors receding.'' Strand compensates by treating the distant figure more vaguely than near objects, such as the vase of flowers, and by placing plenty of warm color in the near objects.

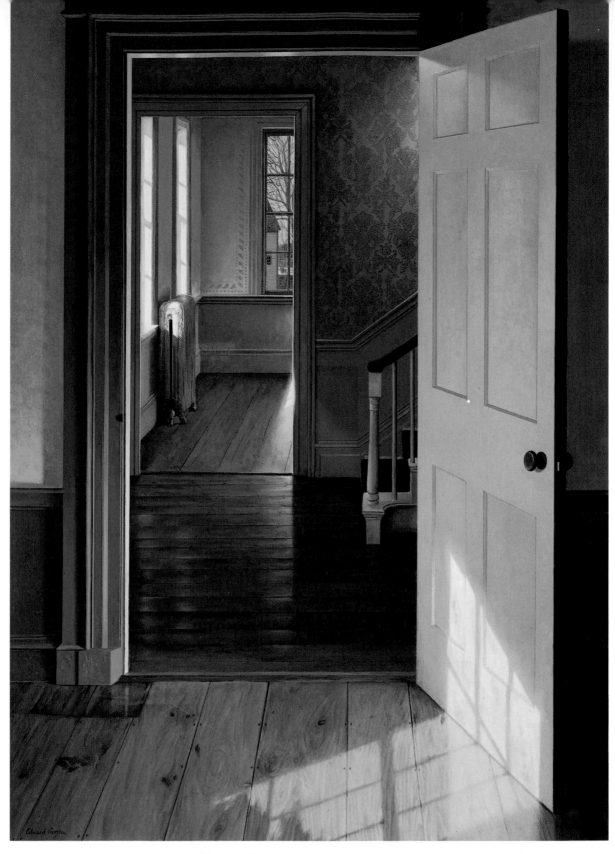

**Empty Rooms**
Edward Gordon
Alkyd on Masonite panel
34″ × 24″

In this scene there is sunlight in all three rooms and also artificial light in the middle room. Working in alkyds (see *Painting Glowing Light With Alkyds* in chapter five) Gordon captures delicate nuances of both direct and reflected light. Notice, for example, that the top of the door is bathed in cool light but the downward-facing edges of the inset door panels running through that cool area have an orange glow. The cool color comes from a window in the adjoining room, and the warm light is reflected upward from the floor. Notice, too, the window light striking the floor and open door. The light on the door, in turn, is *reflected* in the shiny floor.

I once had a student who complained she was going batty because she had purposely set up a single, bright light source on her still life and yet could not get sharp cast shadows. The problem was that what she thought was a single source really was not. She used an incandescent bulb in a reflector shield, clamped to a piece of furniture and aimed at the still life. The filament of the bulb was one light source—obviously the primary one—but light bouncing from the reflector was a second source. The result was a double set of shadows. The truth is, there is hardly any such thing as a single light source.

Even the bulb itself is not perfect because light radiates not only from the filament, but from all parts of the glass enclosure as well, so that light is streaming toward the subject from an infinite number of points. The only perfect single light source would be a point of light without any sort of enclosure.

**What may appear to be a single light source is really a multiple light source.**

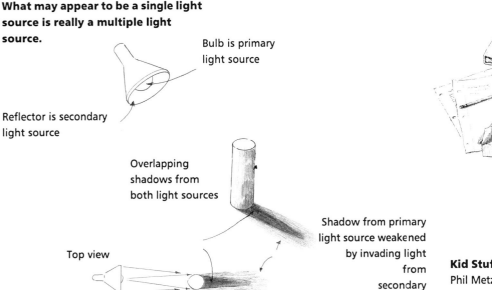

Bulb is primary light source

Reflector is secondary light source

Overlapping shadows from both light sources

Top view

Shadow from primary light source weakened by invading light from secondary light source

**Kid Stuff**
Phil Metzger
Pencil on Morilla Bristol paper
10" × 10"

The reason for the double shadows—a dark one near each object, a lighter one farther out—is that there were two light sources. The stronger and closer source was a lamp, the other, a window. Multiple light sources usually mean multiple shadows, which can add interest to a picture. In cases where there is a profusion of strong sources, all shadows can be washed out. I used individual pencil strokes instead of solid, filled-in passages because I wanted the little flecks of light between strokes to help keep shadowed areas lively.

# Painting With Rubber Stamps

Rather than paint a wallpaper design (like that in *Empty Rooms*, left) with brushes, Edward Gordon uses rubber stamps. First he draws the design he wants in pencil on paper and then darkens the design using a fine felt-tip pen. He shrinks the design to the size he needs on a photocopier. At an office supply store he has a rubber stamp made from the reduced drawing. In this case Gordon had two stamps made, because the wallpaper design included two interlocking images.

He paints the wall area nearly to completion and coats the area with Liquin. Once the Liquin is dry he can test colors and values for the wallpaper images—the Liquin layer allows him to remove the test paint easily without damaging underlying paint. When satisfied with his mixtures, he spreads paint evenly on his palette, presses the stamp into the paint, and applies the stamp to the painting. If dissatisfied, he wipes the paint off, adjusts and tries again.

You can use this method whenever you need a repetitive design on a plane parallel to the picture surface. It will not work for a wall in perspective, because the parts of the design are not all the same size.

## Imagined Light

Artists often make their own light. What they put into their pictures is some combination of light they've actually perceived and light they fashion to suit their artistic aims. I'm pretty much a slave to realistic lighting, so I can only admire those whose imaginative lighting frees them from all the rules. While some artists come by this freedom naturally, others get there by deliberate, sometimes painful, decisions to violate this rule or that. One small violation leads to another, and before you know it, you're free (or a criminal!). What matters when you kick aside any rule or standard in painting is whether the result warrants the transgression—or simply testifies that you don't know what you're doing. That judgment may have to come from your public.

Imaginative interpretations range from Warren Taylor's mystical *Ascending Order* (below) to Mary Sweet's flat-patterned *Early Morning, Bryce Canyon* (page 31, bottom) to Marci McDonald's surreal *Rose From Last September* (page 31, top).

McDonald's comments about *Rose* illustrate the way some artists deal with the idea of not-quite-real light. She says: "I don't really think about a light source as I paint, except that I try to make shadow and light work together to make sense. But if I want a lit place or a deepened shadow to please my design sense, I'll always put it there even if it wouldn't *actually* be there. I almost always find myself trying to make subjects look as if they were lit from within—somewhere just under the skin. . . . I like objects to swell and glow in places and to recede deeply and darkly in others." She feels free to do what's necessary for the sake of the design. Everything you do in a painting should be aimed at improving the design, no matter what "rules" of the real world you might have to violate.

Once you leave the realm of reality, anything goes—there are no boundaries and you're free to follow your imagination and see where it leads. In his demonstration, *Sierra Vieja* (pages 32-33), Warren Taylor marries a foreground still life to a landscape. What I find engaging about such a painting is that it probably holds a different "story" for each viewer. When an artist allows his or her imagination a lot of freedom, the same becomes true for the viewer.

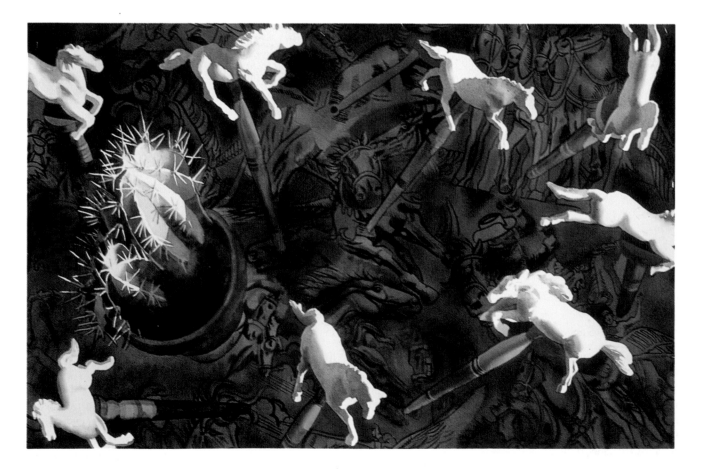

**Rose From Last September**
Marci McDonald
Airbrushed acrylic on paper
32″ × 40″
Collection of Dr. and Mrs. Jeffrey Booth.

This painting is based on D.H. Lawrence's novelette *The Fox*, a dark tale about two women living on a remote farm. One of them has a disturbing encounter with a fox in the woods at the same time that a young man mysteriously enters her life. The two events become tangled and almost interchangeable in her mind. The story gave rise to images that stayed with McDonald for many years before they finally took form in paint.

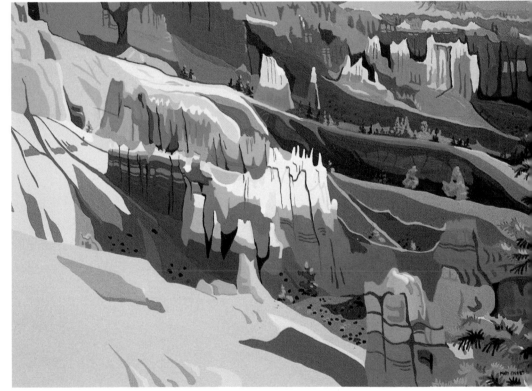

**(Left)**
**Ascending Order**
Warren Taylor
Watercolor
30″ × 40″
Collection of Steve Johnson, Dallas, Texas.

Taylor's paintings often are flooded with light playing against mysterious shadows. This painting deals with the upward release of spirits, the ascension of previously imprisoned souls into pure light and timelessness. The potted cactus acts as observer and sentinel, rising upward to catch the last light of this day.

**Early Morning, Bryce Canyon**
Mary Sweet
Acrylic on paper
22″ × 30″

Here the early morning sunlight is essentially the subject. To capture the drama of the intense sunlight striking the tops of the ridges and rocky spires, Sweet highlighted the backlit ridges and flooded the foreground with yellow-orange. The quality of sunlight brought out every ounce of color in the already color-saturated land, so she let the colors run riot in the painting as in real life. She started with the light she saw and let her imagination take over.

## Demonstration ▪ **Warren Taylor**
# Imagined Light

Taylor specializes in imagined scenes flooded with light. The light he paints generally obeys waking-world rules, and that bow toward realism gives unity to his painting.

**Sierra Vieja**
Warren Taylor
Watercolor
33½″ × 54″

### Step 1
Taylor begins by determining where white and contrasting dark passages will be anchored. He sets the tone for the painting by washing in the sky and then works forward, essentially completing the landscape portion.

### Step 2
He renders the light passages of the still life, taking care to coordinate the feel of the light with that already painted in the landscape.

**Detail**
Notice the careful pencil drawing and the design of the cloth folds that make a transition into landscape.

**Step 3**
In the final stage, Taylor carefully connects the two differing idioms in terms of color, value and texture. With a nod toward realism, he coordinates the shadows on the fractured cliff with those in the still life.

**A Corner of the Universe #1**
Sharon Maczko
Transparent watercolor
25" × 40"
Photo courtesy of Gene Ogami.

Maczko wished to convey a desolate, poisonous surface with gases choking the atmosphere. She fabricated the layout of the terrain on a tabletop, then placed a lamp behind the "mountain" at the right. She hung a dark-colored fabric as a backdrop and draped carefully selected colors of sheer fabric across the foreground. The wispy fabric catching the light gave a streaked, ethereal effect. A small light at the left highlighted the left surface of the larger papier-mâché sphere. Maczko sets the mood she wants with her painstaking constructions, then proceeds fairly conventionally, first doing a drawing and then painting directly from the model without using slides.

**1937 Lincoln Zephyr**
Tom Hale
Acrylic
40" × 30"

Most of Hale's paintings are based on imaginative, often surreal, lighting. His combination of reflected light and moody backlighting transforms ordinary subjects into extraordinary paintings. Notice that the fluid background light is repeated in the equally fluid reflections on the car's hard surface.

**Long Shadows at Taos**
Frances Larsen
Watercolor and acrylic on Strathmore
cold-press board with hand-carved poly-
chrome frame
32″ × 44″ (including frame)

Larsen's intention is to focus on interlock-
ing shapes that move the viewer's eye
across the surface. This watercolor, one of
a series exploring the effects of light on
old adobe surfaces in the Southwest, re-
verses normal color usage as Larsen gives
free rein to her imagination. The center of
interest, the rust-brown Taos Pueblo, is
painted in transparent washes of light,
neutral grays, as though sun-bleached
over the centuries.

## Studio Light

Some artists paint in the dark, some paint under glorious "north light," some are satisfied with a couple of fluorescent fixtures, and a few true-blue *plein air* painters only paint outdoors. What matters most is what sort of light the finished painting is likely to be viewed under. It's impossible to know for sure — many will hang in warmly lit living and dining rooms; others will grace the walls of coolly lit offices; some will be hung under one of those ugly little brass picture lights; and, of course, yours will be hung in the controlled light of a museum.

Most painters try to "split the difference" — paint under light that seems balanced, neither too warm nor too cool. This is easy to accomplish using fluorescent fixtures because there are so many types available. My solution is to use an equal number of "warm white" and "cool white" tubes spread around so that there are no shadows on the work. You might want to consider specially made tubes that manufacturers claim are perfectly balanced for artists' needs. One brand, advertised in art magazines, is called Verilux.

Some artists swear by "north light." I've never had a studio facing north (my current studio doesn't face *anywhere* — it's in a windowless section of my basement). If you live in the United States (except for Hawaii), there is a distinct difference between the light you get through your north-facing and south-facing windows. The light through a *south* window is *direct*, and as the sun travels the southerly sky, the light through your south window shifts markedly. But light coming through your *north* windows is *indirect* — that is, it's light reflected from the sky rather than light coming straight from the sun. That reflected light

shows far less shift in color, intensity and direction during the course of a day. That relatively unchanging character is what artists like about north light. I get the same effect down in my dungeon with unchanging fluorescents!

Whatever your choice of studio lighting, it's a good idea to view your paintings at various stages under other lights, especially when you're nearing completion. Take the paintings into other rooms, even outdoors, and be sure you like what you see. Occasionally, what you thought you painted and what you did paint will be far apart.

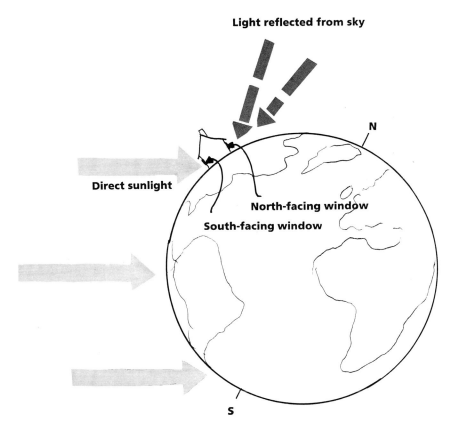

North light, relatively unchanging throughout the day, is indirect light reflected from the sky; south light is rapidly changing direct sunlight. In southern Argentina, everything would be reversed and *south* light would be coveted by artists!

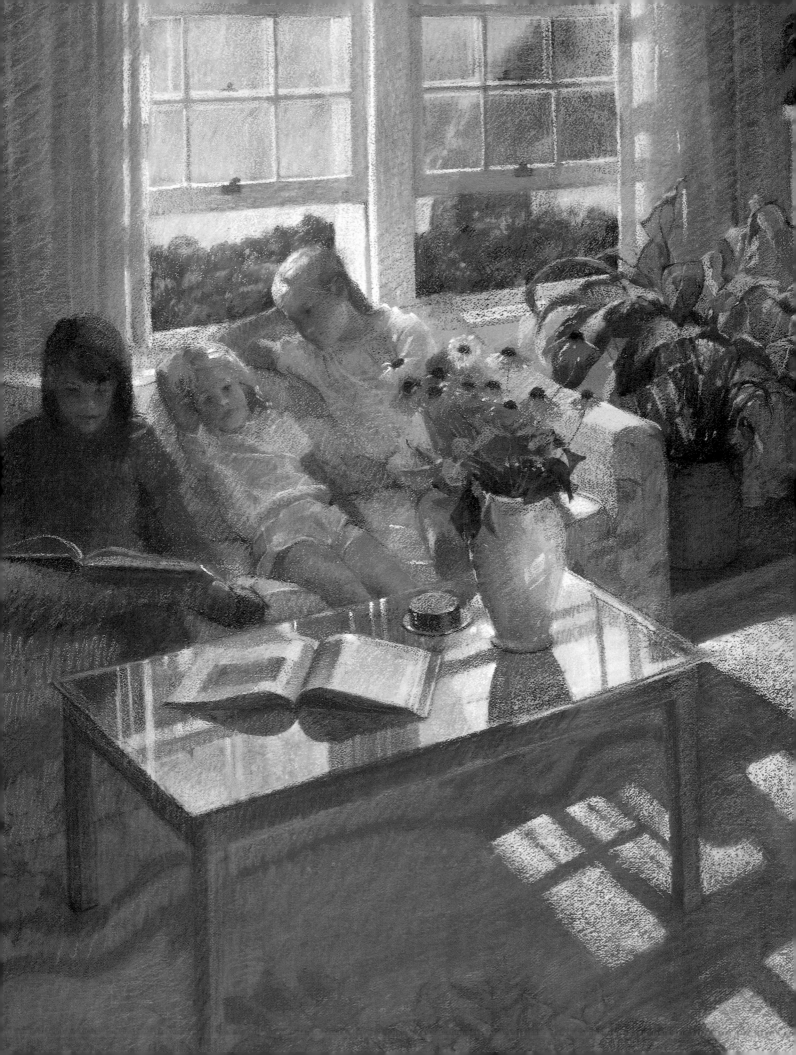

# Chapter Three
# **Shadows**

**Interior With Morning Light**
Sally Strand
Pastel on paper
40″ × 30″

Strand uses large shadow areas as important compositional elements.

When I was young I listened to a radio program (remember radio?) about "The Shadow," a mysterious crime-fighter who could make himself invisible. Strange thing was, he was misnamed because shadows are definitely visible.

Shadows are not only visible, but often bright and colorful as well. One of the biggest mistakes a painter can make is to treat shadows as dull, dark, dead areas. They are full of life. According to Leonardo da Vinci, who had something to say about everything, a shadow is really just a "lesser light."

Before you paint another shadow, look—I mean *really* look—at some shadows around you. Look at them inside your studio, outdoors, everywhere you go. Deep shadows on a sunny highway often have a strong blue cast because of blue light reflected from the sky into the shadow; the shadow of a tree may be greenish where it falls across the grass, but reddish where it hits a dirt road; next to me is a blue notebook casting a shadow on a yellow pad, a *green* shadow! There is much more to a shadow than absence of light.

Besides being colorful and lively, shadows play other roles in a picture: They help define form, texture and depth; they establish mood; and they can even be the perfect shape to unify the pieces of a composition.

## Conditions That Affect Shadows

Although shadows are basically areas receiving little or no light, they're really more complex than that. At least a half-dozen conditions may influence the look of any shadow. Given an understanding of what those conditions are, you are free to manipulate them all to get the result you're looking for in your painting.

**Nature of the Light Source.** If there is a single source, such as the sun, shadows may be sharp and dramatic, as in Michael Rocco's *Plaza in Granada* (below). But if the light comes from a number of sources, as in Lena Liu's *The Music Room* (page 41), shadows will be noticeably softened because light

from one source weakens the shadow produced by another source. Even a single light source can produce strange shadows that appear to be caused by multiple sources. A good example of this is direct sunlight entering a south-facing window and casting shadows in one direction while indirect, reflected sunlight enters a north window and casts softer shadows in the opposite direction. We saw this phenomenon in Sally Strand's demonstration in the last chapter.

The *brightness* of the light source also has plenty to do with the shadow—a brilliant sun unimpeded casts relatively sharp shadows, but sunlight diffused through fog, mist or polluted air, or sifted through gauzy curtains, may produce fuzzy shadows.

**Plaza in Granada**
Michael P. Rocco
Watercolor
22″ × 29″

Long cast shadows instill a sense of quiet, a hint of wonder. We always look into a shadow to see what's there. Of the strong foreground shadow, Rocco says, "Without it the painting would be an ordinary scene of a typical European town." He set out to capture the right amount of detail in the shadow area, "but yet to do it with restraint and an air of mystery."

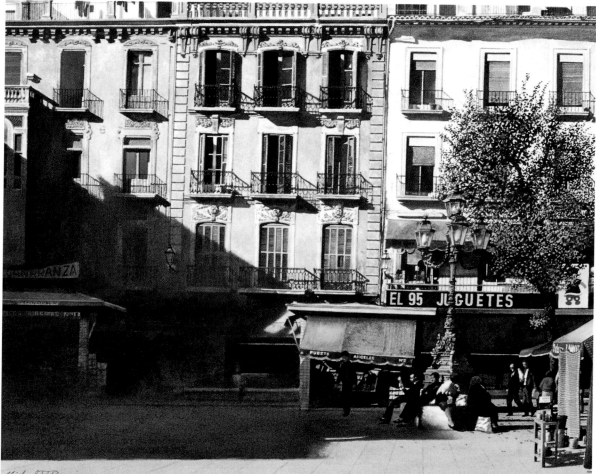

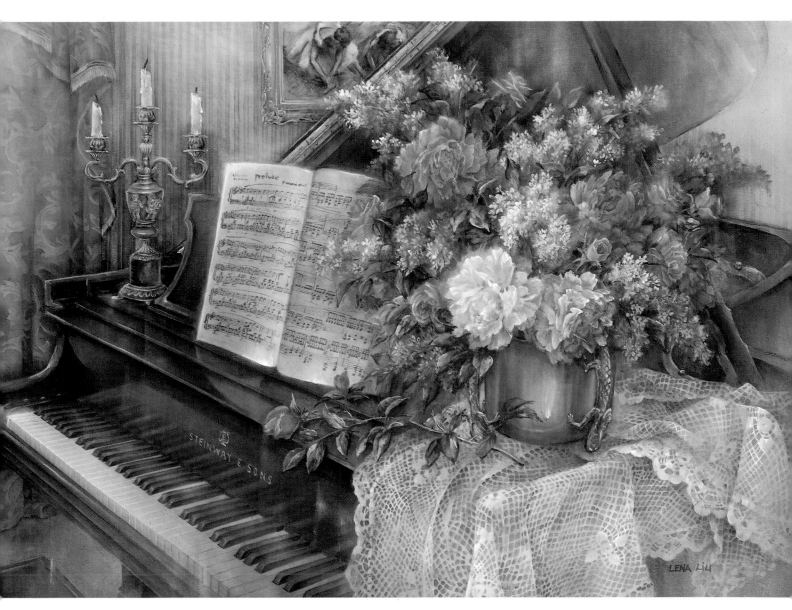

**The Music Room**
Lena Liu
Watercolor on silk
22" × 32"

This scene is flooded with natural light from several windows, and artificial light as well. Liu worked both from photographs and the actual arrangement around husband Bill's piano. After first doing a thumbnail painting to judge composition and color, she began the full painting by flooding the silk (stretched on canvas stretcher strips) with loose general color. The paints Liu uses are a combination of traditional transparent watercolor and oriental mineral color, similar to gouache.

**Nature of the Object Causing the Shadow.** A solid object, such as a wood post, usually casts a strong, hard-edged shadow, while a transparent or translucent object, such as a glass jar, casts a lighter, less consistent shadow. The reason the jar's shadow is not uniform is that some of the light passing through the jar is deflected (see chapter four) and ends up striking odd parts of the shadow area. The same effects can be seen in the broken shadow of the bowl and the unbroken shadow of the small blossom at the lower left in Susanna Spann's *Stolen Moments*.

Another phenomenon that affects cast shadows is *diffraction*, the slight spreading of a light ray as it passes by the edge of an opaque object. The result is a slight fuzziness at the shadow edges as the spreading light invades the shadow area. The effect is more pronounced at the end of the shadow farthest from the object.

**Stolen Moments**
Susanna Spann
Transparent watercolor on 300-lb. Arches
49″ × 24″
Collection of Jeffrey and Patricia Aresty, Coral Springs, Florida.

The shadow cast by the glass bowl is not uniform in value or color because it is modified by light passing through the bowl. That light is bent and deflected by the varying thicknesses of glass and by the water in the bowl, and emerges in odd patterns to strike the shadow area. This phenomenon, refraction, is covered in the next chapter.

**Texture of the Shadowed Surface.** Smooth surfaces will yield relatively smooth, sharp-edged shadows. Rough surfaces, however, will show unevenness at the edges and value variations within the shadow because any light entering a rough area tends to be scattered by countless small reflectors—blades of grass or the nap of a carpet, for example. You can easily test this by performing a little experiment. Darken your room and lay something smooth, such as a piece of paper, on your carpet. Hold an object such as a ruler an inch or two above both surfaces and use a flashlight to cast a shadow on both. You'll see a clear difference between the shadow on the paper and that on the carpet. The rougher the carpet, the greater the difference.

Smooth surface

Grass

**Winter Stalk**
Allen Blagden
Watercolor
22″ × 30″

This is Blagden's pet bobcat. The shadows painted over smooth snow are relatively sharp; those over the rough tree bark are broken and less sharp-edged.

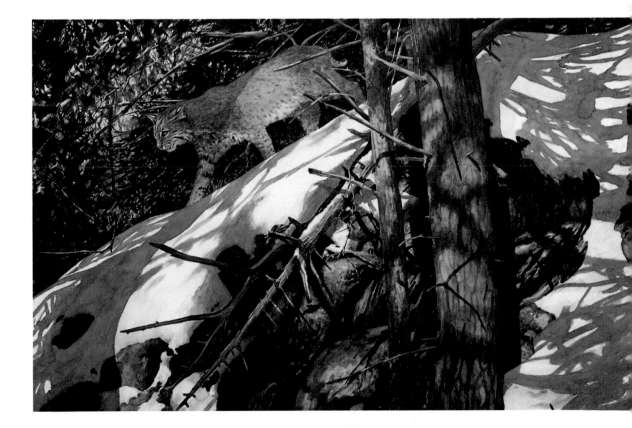

**Color of the Shadowed Surface.** Shadows are not slabs of black; their colors are greatly influenced by underlying colors. Painters are divided in their approaches to handling basic shadow color. One group paints *directly*, obtaining the shadow color using a darker version of the color the surface has without shadow; it's the method used by Don Stone in his moonlit scene at the beginning of chapter two. Others paint shadows by glazing. Glazing, in this case, means first painting the area the color it would be with no shadow and then, after letting it dry, laying down transparent layers of paint until the area looks subdued enough. It's the method used by Stephen Sebastian in his watercolor demonstration, *Midafternoon*, on pages 46-47.

When opting for the glazing method, there is always the question, What *color* glaze? Using cool colors—blues, greens, purples—works well because the area adjacent to the shadow is lit by the sun or other relatively warm-colored light, and placing cool shadows adjacent to the warm areas heightens the contrast.

**Colors of Surrounding Areas.** Light of various colors will always be reflected from nearby surfaces *into* the shadow, thus modifying its "basic" color. Try placing a colored object such as an apple close to the shadowed side of a white cup. You'll see clearly that the color of the apple greatly modifies the "gray" shadow on the cup. Including colors in shadows helps give them life.

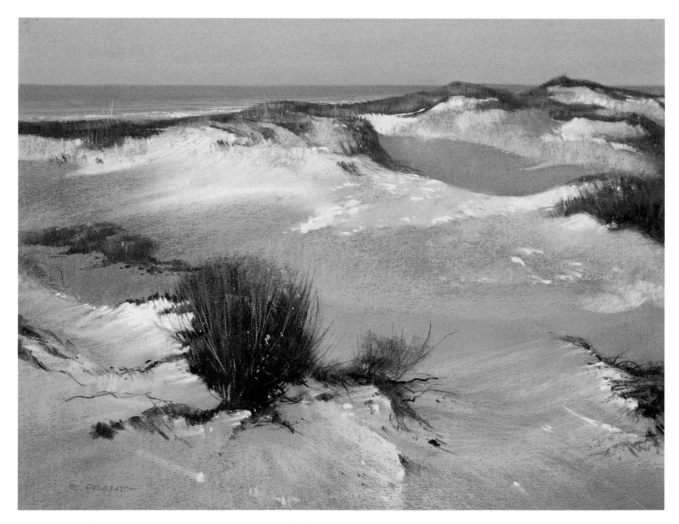

**Navarre Beach**
Robert Frank
Pastel on paper
19" × 25"

Who says shadows are colorless? These shadows on white sand are color-drenched. The color comes from (1) the many colors inherent in "white" sand, (2) sky reflections, (3) reflected color from surrounding objects, and (4) most important of all, the artist's imagination.

## Position of the Light Source.

Changing the location of a light source relative to the object causes emphatic changes in the resulting shadow. To take just one example, an object under the sun around midday casts a short, sharp shadow, but hours later that same

**Midday sun**     **Later sun**

object casts a longer and fuzzier shadow, lighter in value at the end farthest from the object. The fuzziness and lighter value occur partly because of diffraction, but mostly because the farther a shadow is from the object casting it, the more chance there is for extraneous light to be bounced into the shadow.

It's also important to understand that while the position of the light source critically affects the length and direction of shadows, it has no effect on *reflections*. Shadows and reflections are distinctly different critters, as we'll see in the next chapter.

**Sunny Retreat**
Gustave Wander
Watercolor on Lanaquarelle paper
22″ × 30″

Wander likes this French paper for its whiteness and because it allows the lifting of color from its surface. He prepares to paint by soaking the paper and stapling it to a Homosote board. Like most of Wander's paintings, this one is filled with light and shadow. In this case the large cast shadow at the right unifies the composition and helps focus attention on the porch area with its wicker furniture. Notice that all the shadows are varied by the presence of light reflected into them. The strong reflections of the white chair and table legs break through the cast shadow; the direction of those *reflections* will remain constant while the locations of the *shadows* will change with the shifting position of the sun.

## Demonstration ▪ Stephen Sebastian
# Painting Luminous Shadows

Sebastian is drawn to shadows cast on white surfaces and is intrigued by their varying degrees of color and brightness. Like most water-color painters, he usually paints shadows *over* a dry, previously painted surface — i.e., glazing. Sometimes the surface over which the shadows fall is white, as here, but often the surface will be full of color before shadows are applied.

**Midafternoon**
Stephen Sebastian
Watercolor on Arches 400-lb. cold-press paper
20″ × 28″

### Step 1
Sebastian soaks the paper and staples it to ¾-inch plywood. When the paper is dry and taut, he starts with a fairly detailed drawing and then masks off the paper's edges with drafting tape to retain a clean, white edge. He likes, in later stages, to re-move the tape for a value check. Sebastian also covers the edges of the building with masking fluid to protect the white paper until the sky is painted, and then removes the masking. The sky color is a mixture of ultramarine blue and brown madder.

### Step 2
Using the same color combination as for the sky, he paints the cast shadows, after first masking the roof shingles. The mask-ing allows him to paint the shadows more rapidly and smoothly.

**Step 3**

He now works to bring depth, warmth and contrast to the shadows. He does so by lightening some areas and darkening others. The lightening is done by wetting an area and gently removing some paint; the darkening is done by adding light washes of raw umber and ultramarine blue.

**Step 4**

He paints the overhanging roof shingles and sharpens details over the entire painting: nails, stains, cracks in boards, spaces between the louvered slats, joints between boards. Notice the attention to lovely little details, such as the breaks in the cast shadows where there are spaces between roof shingles, allowing sunlight to pass through.

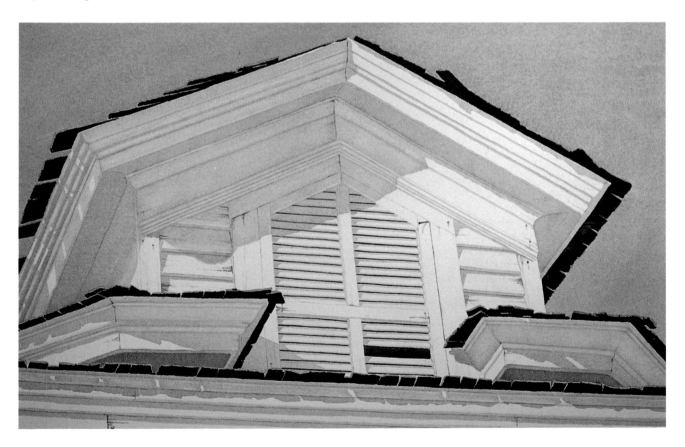

## Cast Shadows

A cast shadow is formed when one object blocks light from striking another surface. Such shadows frequently set the tone, or mood, of a painting. Rocco's *Plaza in Granada* (page 40) and Gatewood's untitled piece (below) rely heavily on cast shadows for their impact. Both paintings have an air of mystery that would be absent if the cast shadows were removed. Long, slanting shadows seem to invite the eye to probe.

Cast shadows serve the painter in more ways than by simply providing mood. They help define the *shapes* of surfaces on which they fall. Look at the windows, for example, in *Granada*. Each is set in deep relief because the sunlight streaming in from the upper left causes sharp shadows to be cast to the right and under the frames and sills. Those shadows emphatically *define* the windows. Similarly, the decorative brackets and cornices

along the edge of the roof are given shape and solidity thanks to the shadows they cast. While defining underlying shapes, shadows themselves become interesting shapes — indeed their shapes are often the subject of a picture.

In addition to defining the basic *forms* of objects, shadows help describe *textures* as well. In figure *a* (page 49, top), the light is directly from the front and there is little definition of the brick and clapboard wall. But in figure *b*, a raking light from the upper right gives the wall character by causing many small, sharp cast shadows that, taken together, say "texture."

There is a curious occurrence of cast shadow that may at first seem "wrong": A shadow may appear without obvious benefit of a light source. In the illustration on page 49 (center), the roof overhang casts a shadow, as we might expect, on the side of the building. But why do the protruding beams, which are themselves in shadow,

seem to be casting their *own* shadows up against the overhang? There is apparently only a single light source — the sun high above — so how can these beams be casting shadows upward? The answer is that there is actually a second light source: sunlight reflected from a surface below the beams — in this case a light-colored lower roof. Such relections can also be caused by a whitewashed wall, a bright gravel walkway, a shiny floor and so on. In fact, it's rare that a scene truly has a single light source — there are almost always reflections to act as added sources.

Another intriguing phenomenon is that of overlapping shadows. These are the result of multiple light sources, discussed in the last chapter. There can be any number of shadows overlapping and crossing one another; exactly what effect you get when shadows overlap depends on the arrangement of lights and objects. As a rule, wherever shadows overlap, they reinforce one another so that the area of overlap is darker than the rest. Notice that the two objects in the illustration on page 49 (bottom) each cast two shadows because there are two light sources. There are three places where the shadows overlap, and where they do they are darkest.

**Untitled**
Charles Gatewood
Egg tempera on Masonite panel
8″ × 8″

Soft light and long shadows lend an air of mystery. One wonders what souls have passed through this schoolroom and scribbled on these blackboards.

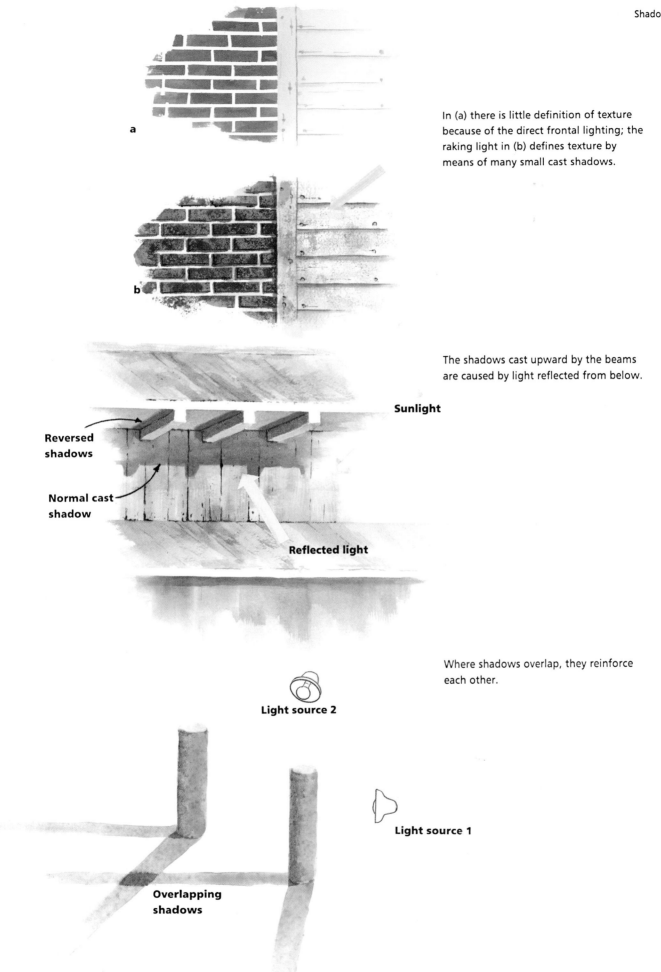

In (a) there is little definition of texture because of the direct frontal lighting; the raking light in (b) defines texture by means of many small cast shadows.

**a**

**b**

The shadows cast upward by the beams are caused by light reflected from below.

**Sunlight**

**Reversed shadows**

**Normal cast shadow**

**Reflected light**

Where shadows overlap, they reinforce each other.

**Light source 2**

**Light source 1**

**Overlapping shadows**

## Modeling

Modeling is the general lessening of light as a form curves away from the light source. One might think, given a single light source and a simple rounded object, that modeling would be a straightforward matter, but of course it's not. Very little is straightforward where light is concerned!

Consider Michael Weber's *Still Life With Granny Smiths* (below), where light is bouncing all over the place. The light source is at the right, so one might expect to see a gradually deepening shadow wrapping around the white pitcher, becoming darkest at the edge next to the basket. Curses! Foiled again! Just look at all the bright light reflected *into* the shadow area. That light comes from the cloth, as well as the silver bowl; there's even a good bit of green, thanks to the apples. The two white containers at the left show the same phenomenon—their shadowed sides are beautifully altered by reflected light

from the cloth and other objects. There's a similar effect in the lone green apple. Its lower left shadow area is lit by reflected light from the cloth; there's even a little dimple of light reflected from the bowl, on the apple's upper left shoulder.

Notice, too, some of the *cast* shadows in this painting. The small white container at the left is casting a shadow on the larger container next to it. That cast shadow is sharper and darker, as is so often the case, *nearest* the object casting the shadow, and it becomes gradually lighter and softer-edged farther away. Other shadows are treated with care—those in the crisp basket are stronger, harder-edged, while those in the cloth are softer. At the right, Weber supplies some shadow on the backdrop to help guide your eye into the picture.

Robert Brawley has mastered the use of light in many media. On page 51 (top), in alkyd and oil, he displays an exquisite touch in seeking out and defining the many nuances of light and shadow among

the folds of the blouse, around the woman's head and hands, and across the wall behind her. Notice the gentle transition of the head into shadow, the hair melting into the background. The brightly lit right side of her face and her right hand are presented against a dark background, but are rescued from starkness by finely modeled edges. Everywhere you look, some form is receding from the light in a natural, gentle way.

As you can see from these examples, a modeled shadow is full of pleasant distractions—such shadows are no more flat or dead than cast shadows. If you carefully study any shadow, you'll be rewarded with an unending series of discoveries that may revive an otherwise comatose painting. Because so many delightful aberrations can be found in any subject, it's risky to paint too much from memory unless your memory and imagination are unusually sharp.

**Still Life With Granny Smiths**
Michael J. Weber
Watercolor
22" × 28"

This still life is full of modeling, cast shadows and reflections. Notice that every shadow wrapping around a form is invaded by strong light reflected from other objects.

## Backlighting

Backlighting is the placement of the light source *behind* the subject. The observer is looking directly into the light and tends to be partially blinded by the glare. The result is that relatively little detail can be seen in the subject, which tends to appear flat. Backlighting offers the opportunity for a dramatic painting with strong silhouettes, but because of the flattening of forms, there is also the opportunity for a stinker!

Artists have various ways of cashing in on the dramatic possibilities of backlighting and avoiding the danger of flatness. In *Porcelain 'n Linen* (page 52), Wayne Waldron uses reflected light to help model an otherwise flat shape, the pitcher. Light is reflected from the bowl in front of the pitcher back onto the pitcher and provides just the right modeling illumination. As for the bowl itself, we have no problem grasping its roundness because Waldron chose to place it a little below eye level, thus showing its curved rim and allowing us to see down into it.

Ted Becker uses a similar technique in *Westside* (page 52). The building is rescued from being flat and featureless by the presence of enough reflected light (some from the ground, most from the sky) to show detail in the side facing us.

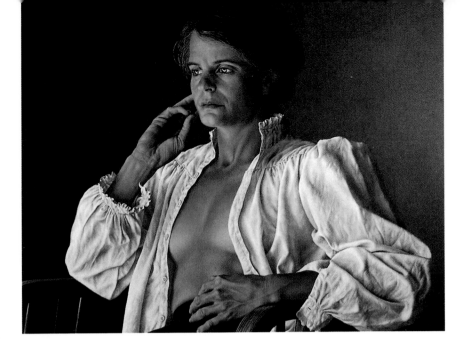

Warren Taylor, whose unrestrained imagination is a constant delight, backlights a row of spurs in *Cotton-Eyed Joe* (page 53). Taylor began by painting cowboy designs on the horizontal plane where the spur-figures are standing, using rich colors that perfectly support the golden "sunlight." Having masked the sun and spur-figures with acid-free masking tape, he worked from the sun outward in expanding washes of glowing color.

Notice that in each of the three preceding paintings, the shadows cast by the backlit objects spread toward the viewer like the spokes of a half-wheel. They behave in a way similar to perspective lines that meet at a vanishing point on a distant horizon. This will always be the pattern if there is a single source of backlighting; multiple sources would produce an overlapping set of spreading shadows.

**Woman in a White Blouse**
Robert J. Brawley
Alkyd and oil on wood panel
22" × 26"
Collection of Mr. and Mrs. Robert W. Miller, Bethesda, Maryland.

"The problem was the strong light on the white blouse," says Brawley. "I wanted to reduce the contrast on the folds of the white blouse but hold the brilliant radiance. I used a translucent curtain, which did diffuse the light but allowed the left side of each form to be crisply lit, creating a strong sense of a leftward source of light. I situated the model to get maximum contrast from the darker background. I was careful to render the background with a gently shifting half-light, drawing the eye right. I was then able to develop the rich midtones of the skin, mediating the extremes of light and dark. The raking effect of the sidelighting emphasizes the volumes and structures of the forms."

In a backlit scene, shadows radiate from the light source like spokes in a wheel.

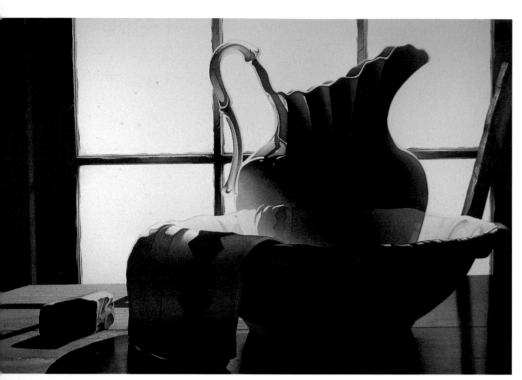

**Porcelain 'n Linen**
Wayne Waldron
Watercolor and acrylic
22" × 30"

Waldron makes skillful use of light re-
flected from the bowl back to the pitcher
to help define the pitcher's form. In this
design, two features are prominent: (1) He
arranges major light and dark shapes for
dramatic visual impact, and (2) through
patient glazing, he introduces the right
amount of color and value transition to
keep these backlit shapes from appearing
flat and lifeless.

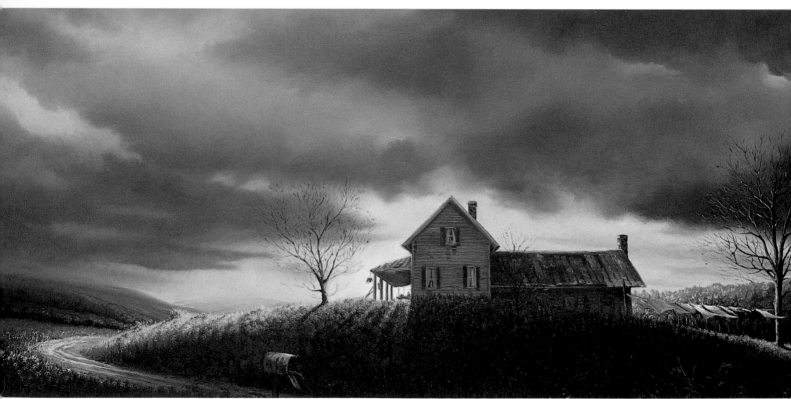

**Westside**
Ted Becker
Oil on canvas
15" × 30"

Backlighting provides both a dramatic set-
ting, or mood, and the opportunity to
play up strong value contrasts. Reflected
light, mostly from the sky, illuminates the
face of the building just enough to show
some defining detail.

## Cotton-Eyed Joe
Warren Taylor
Watercolor
23" × 35"

In a work that pokes fun at the Texas line dance bearing this name, spurs arranged in a row dance into the sunset. The backlit spurs cast shadows onto a flat, figured surface that features a comic, wild West theme, while three spurs create a spectator foreground. The sunset acts as a backdrop and its light unifies the event.

## The Mind at Play #1
Sharon Maczko
Transparent watercolor
23" × 37"
Photo courtesy of Gene Ogami.

Like Warren Taylor, Maczko invents her scenes. "For this painting," she says, "I wanted the sumptuous orange-pink glow to be the basic element in the creation of a make-believe world. After draping a rose-colored blanket over several chairs, I placed one high-wattage lamp behind it to flood the main area with light, and one lamp at the left to highlight the bottom edge of the blanket. Backlighting dramatically changes the color and texture of fabrics and objects, in this case creating a luminous environment for the imagination."

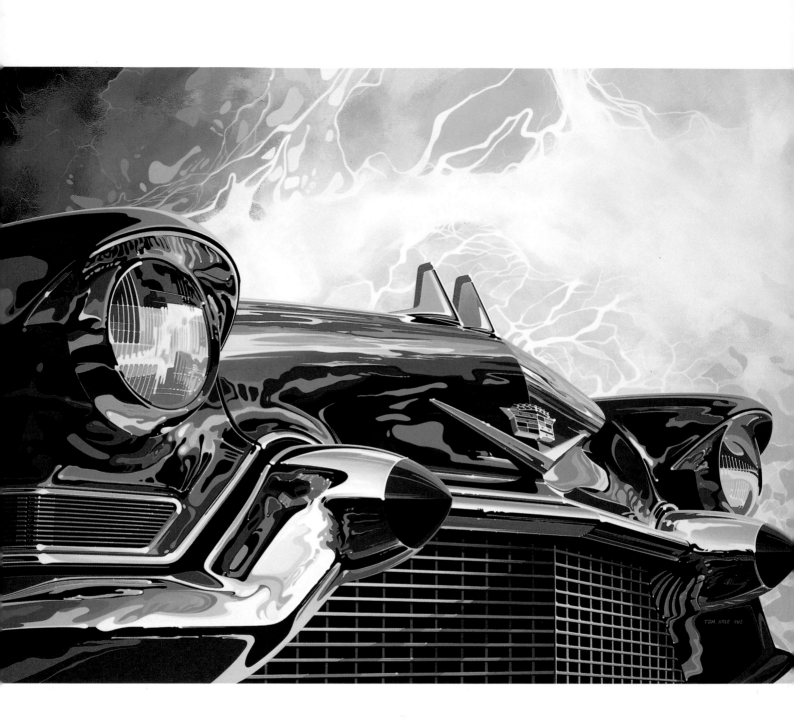

# Chapter Four
# **Reflections and Refractions**

**1957 Cadillac**
Tom Hale
Acrylic
30″ × 40″

The curved reflections that enliven this subject are echoed by the flowing abstract light patterns in the background.

We think of light as traveling in straight lines, but like most things we learn in high school physics, that's a partial truth, something like the solemn vows of a politician. Light may *want* to go straight, but all kinds of things influence it to do otherwise. In cosmic terms, light is bent by the gravitational pull of a planet; on earth, light is rerouted by such ordinary substances as air, water and glass.

Light that changes course accounts for the "twinkle" of stars; it's responsible for mirages, reflections on a lake and fuzzy shadow edges; it's what makes your eyeglasses help you see better; and it accounts for those strange blobs of color around the edges of a thick glass vase.

Painters should be thankful for the errant ways of light, because those wanderings from the straight and narrow often become the spark that energizes a painting. There are two kinds of waywardness: reflections and refractions. Reflections happen when light *bounces* from a surface on its way to your eye; refractions are the result of light veering in its course as it passes *through* various substances on its way to your eye. Sometimes reflections and refractions are minor players in a picture, but often they are what the picture is all about.

## Reflections

Although we often think of reflections in connection with flat surfaces, such as bodies of water, they can occur in surfaces of any shape. The reflections in Tom Hale's *1957 Cadillac* twist and curve to bring vibrant life to this subject. Hale starts with real reflections and then pushes and exaggerates them in his painting—having spent many years in automotive design, he can take artistic liberties with confidence. In stark contrast to Hale's curved reflections, Allen Blagden deals with familiar reflections in water in his demonstration, *The Inlet*, on pages 58-59.

**What Is a Reflection?** Most images are the result of light coming directly from some object to your eyes. A *reflection*, however, is an image formed by light that has reached your eyes only after bouncing from an intermediate surface. In sketch *a* (right, top) the observer sees the tree across the pond because light travels directly from the tree to his eyes. In sketch *b* he sees a *reflection* of the tree because light from the tree strikes the water's smooth surface and bounces up to his eyes. Usually he will see a combination of *a* and *b*.

That's all there is to a reflection, except that bouncing light doesn't just jump around at random. It behaves according to a rule of physics: When light is reflected from any flat, smooth surface,

*the angle of incidence equals*
*the angle of reflection*

as shown in sketch *c*. Under normal conditions light will never bounce as in sketch *d*.

Knowing just that much, you can visualize whether a reflection makes sense in a given situation. Suppose, for example, you're painting some trees across a lake. You see the trees reflected in the water and you have no problem painting those reflections. But now you de-

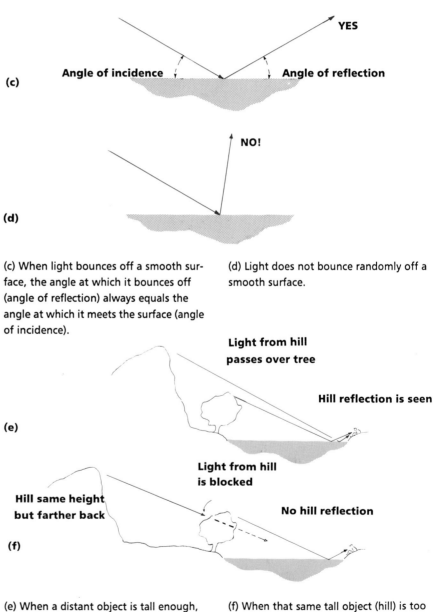

(a) We see objects because light travels directly from the object (tree) to the eye of the viewer.

(b) A reflection is seen when light travels from the tree, then bounces off the water to the viewer's eye.

(c) When light bounces off a smooth surface, the angle at which it bounces off (angle of reflection) always equals the angle at which it meets the surface (angle of incidence).

(d) Light does not bounce randomly off a smooth surface.

(e) When a distant object is tall enough, its light will pass over closer objects to produce a reflection.

(f) When that same tall object (hill) is too far in the distance, the light will be at a low angle by the time it reaches the nearby tree and will be blocked by it, yielding no reflection.

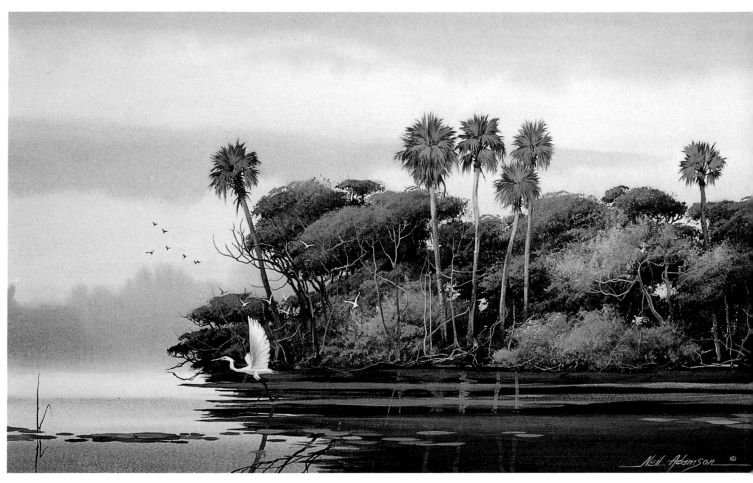

cide to add a (nonexistent) hill in the distance behind the trees. You're an artist, so you're allowed to do that. But, you wonder, would you see a reflection of that hill in the water?

The answer is an unqualified *maybe*. If the hill is high enough that light from it can pass over the treetops, strike the water, and still bounce up to meet the observer's eyes (angle of incidence equaling angle of reflection), the observer will see a reflection, as in sketch *e*. But if the hill is so low that light from it is blocked by the trees, the observer will see no hill reflection. You can play with this situation and get just about any answer you *want*.

Suppose you kept the hill the same height but moved it farther into the distance (sketch *f*). Now the light from the hill is blocked by the trees and the observer sees the actual hill in the distance, but no *reflection* of the hill. As you can see, you have lots of leeway in placing objects so that they either do or don't reflect.

**Homosassa River**
Neil H. Adamson
Acrylic on illustration board
14″ × 18″

Along this river often painted by Winslow Homer, Adamson still finds much unspoiled beauty to paint. Here the strong reflections are kept from becoming too busy by treating them as large masses, broken only by a few tree trunk reflections and horizontal streaks that establish the flatness of the water. The variety of greens was mixed using phthalocyanine blue with raw sienna, raw umber and yellow oxide. Reversing the usual procedure, Adamson painted the trees and reflections first, the sky and distant, misty trees last.

**Demonstration ▪ Allen Blagden**
# Painting Reflections in Water

Wouldn't you paint an object first, and then its reflection? Not Blagden. There was a time when painters, especially watercolorists, were admonished by all the learned teachers to proceed one, two, three . . . and not deviate. Thank goodness, we've become liberated from many needless rules.

In a painting like this, with such a dark mass representing the land and an equally dark mass for the adjacent reflections, it's usually a good idea to do something to separate the two dark areas for visual clarity — hence, the thin line of highlighted objects along the water's edge.

**The Inlet**
Allen Blagden
Watercolor
30" × 22"

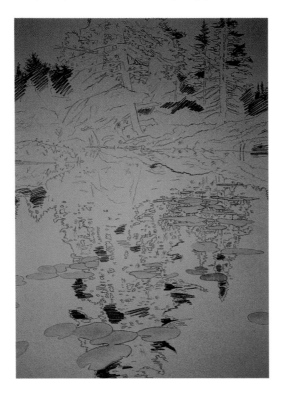

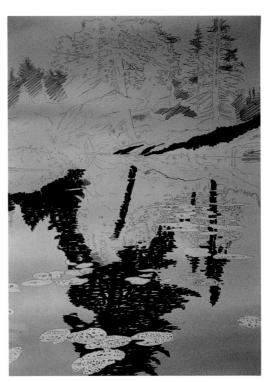

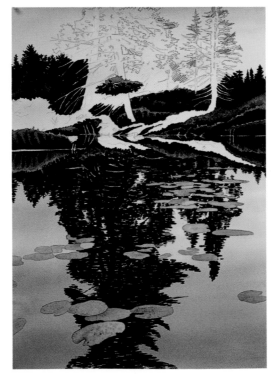

### Step 1
Blagden pencils in all the important shapes, including the tree forms and their reflections. He paints the lily pads olive green and when dry covers them with Maskoid.

### Step 2
He washes the entire paper with a light pink tone to begin suggesting twilight color, then adds gray tone toward the bottom of the picture. He also begins the dark reflections.

### Step 3
With the reflections nearly finished, Blagden removes the Maskoid from the lily pads. Against the dark reflections the lily pads are too light for a twilight scene, so Blagden darkens them. He begins laying in the trees.

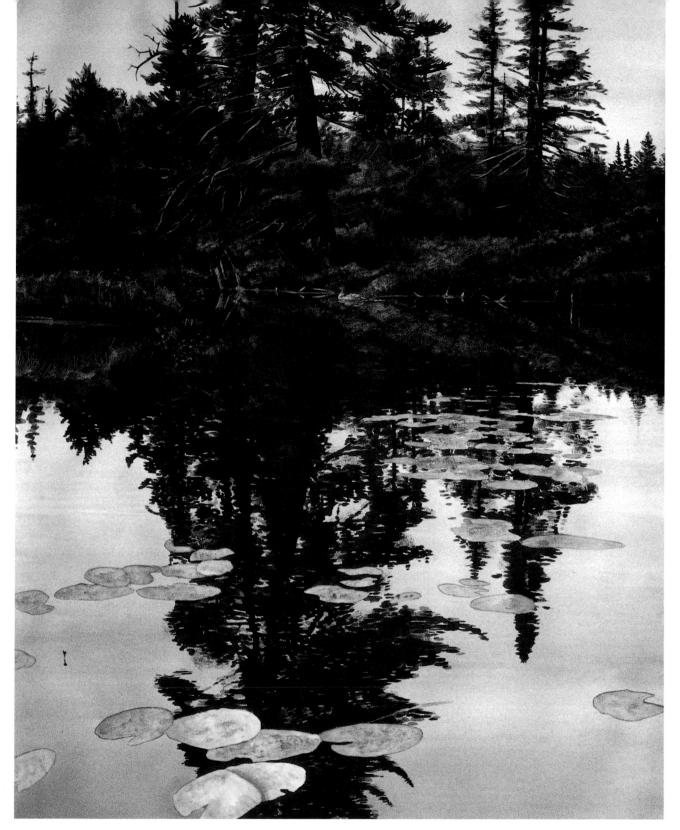

**Step 4**

He finishes the trees and shoreline reeds, painting them with dark, earthy greens in a silhouetted fashion, then modifying the darks with touches of ochre and umbers. The bit of light left at the water's edge separates the dark shore from the dark water. Blagden takes care to make all reflections "lean" in the same direction as the objects without being too rigid.

**Direction of a Reflection.** Light rays bouncing from a smooth, flat surface don't make erratic bounces. They leave the surface at the same angle at which they strike it. They also don't bounce wildly right or left, but remain "in line." That is, a given light ray stays in the same vertical plane when it strikes the surface and when it bounces away. Because of this, the "lean" of a reflection can always be predicted. The reflection of a vertical object is always vertical; the reflection of a leaning object always leans in the same direction as the object.

Occasionally there is confusion between reflections and shadows, and people sometimes carelessly use the words interchangeably. A *shadow* is a relative absence of light caused by some object blocking the light source. If you change the position of the light source, you change the position, and possibly the length and shape, of the shadow. As the sun "travels" the sky, shadows cast by objects constantly change in length, direction and shape. *Reflections*, on the other hand, are independent of the light source. Move the light source all you want and the length, direction and shape of a reflection stay constant. Only in certain odd situations will an object's shadow and its reflection coincide. Normally the two will be entirely separate, as shown at right.

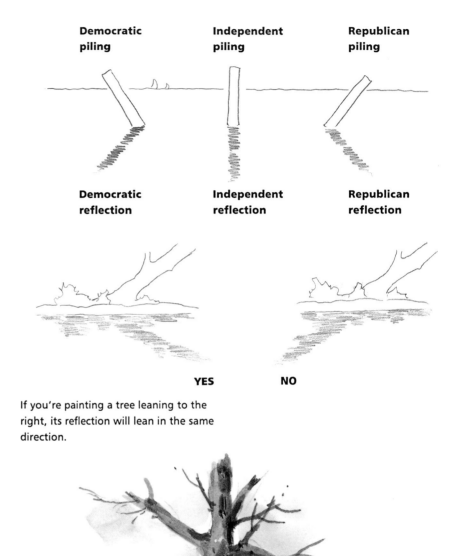

If you're painting a tree leaning to the right, its reflection will lean in the same direction.

**Length of a Reflection.** A reflection may appear to be the same vertical length as the object being reflected, or it may be shorter or longer. Two factors that determine length are the tilt of the object and the position of the observer. If we tilt our piling toward the observer, the length of its reflection becomes greater, relative to the perceived length of the piling. Tilt the piling backward, away from the observer, and its reflection becomes shorter — again, relative to the apparent length of the piling.

The observer's position is important. Suppose one observer is near water level and a second is high above, on a cliff, as shown in the sketch at bottom right. A strange thing happens. Observer 1 sees a shorter reflection than observer 2, even though reflection 1 is actually stretched out over a longer span of water. The reason the reflection seems so short is that observer 1 is seeing a *foreshortened* reflected image. It's like seeing a long piece of lumber from one end — it may be twenty feet long, but it may appear only inches long. Observer 2 is seeing reflection 2 with less foreshortening. So observer 1 will paint a short reflection, and observer 2 will paint a long reflection, compared to the height of the trees.

One can actually calculate the sizes of reflections versus reflecting objects for any set of conditions, but that's of no concern here. What's important to the painter is to understand why reflections change under various conditions. *Most* important, of course, is that you observe, photograph and sketch reflections to get a feel for how they behave. Given enough observation and understanding, you can even invent reflections in your paintings and make them convincing.

**Color and Value in a Reflection.** Although the color of a reflection generally approximates the color of the object, there are many exceptions. The reflection of a yellow pear in a blue bowl may appear greenish; the reflection of a white object in a colored surface may appear to be a weak version of that color, not white; the reflection of an object in a body of water may be much altered by the color of the water and by the color of the sky, also reflected in the water. All of these conditions depend on the relative brightnesses of the various colored surfaces — an intense color can easily overwhelm a weak one (which is no different from what happens when a strong pigment is mixed with a weak one on the palette).

Besides color, the *value* of a reflection is affected by surrounding conditions. I've read that the value of an object's reflection is always lower than the value of the object. Although that's most often the case, sometimes the reflection of an object appears lighter than the object because of conditions surrounding the reflection, the same sort of value illusion we saw in chapter one. Confusing? There's always the simple way out: Paint what you see, illusions and all.

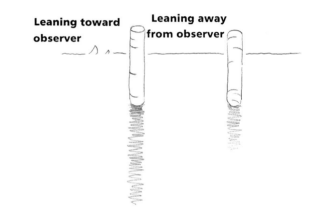

**Leaning toward observer**    **Leaning away from observer**

The reflection of an object is lengthened when the object tilts toward the viewer, and shortened when it tilts away.

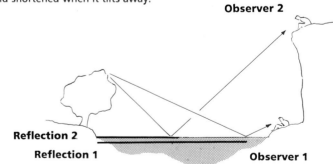

**Observer 2**

**Reflection 2**

**Reflection 1**    **Observer 1**

A strange thing happens in regard to what the observer sees relative to his position. Even though reflection 1 is longer than reflection 2, observer 1 will *see* (and paint) a shorter reflection because of the foreshortening that occurs from his viewing angle.

# Using a Mirror to Study Reflections

You can solve many reflection problems by using the sort of setup pictured here. Simply lay a mirror flat on a table, arrange various objects on or around the mirror, and observe their reflections. If there's no mirror handy, lay out a sheet of black matboard or shiny material, such as smooth aluminum foil, and cover it with a sheet of glass. Here are a few observations that can be made from the illustrated setup:

● The two cutout "hills" are of equal height, but show unequal reflections because of their distances from the edge of the mirror.

● The "sun" is at the upper left, so objects cast shadows toward the right; moving the sun would change the shadows, but not the reflections.

● You can see things in the reflection that you can't see in the object—e.g., the underside of the roof overhang.

● Vertical objects yield vertical reflections; tilted objects give tilted reflections.

Try changing the positions of objects and note the effect on their reflections. Move from right to left and notice that reflections "follow" you—each pair of eyes observing such a scene sees a somewhat different set of reflections. Sometimes it's helpful to have someone move the objects for you as you observe from varying positions. Most observations can be made in full room light, but you might also turn out the lights and have someone hold a flashlight to represent the moon. You can simulate a lake by carefully squirting water droplets into the air so that they gradually fall onto the mirror. You'll see some blurring of the flashlight image. You can get a similar effect by pouring enough water over the mirror to form a "puddle" and having someone gently blow across the surface to form ripples.

**Sharp Versus Fuzzy Reflections.** In Tom Hale's *1957 Cadillac* (page 54) you can see the behavior of reflections in smooth surfaces: They're sharp and clear. Likewise, in my *Reflections With Bouquet* (page 63, top), the reflections are shown as fairly sharp images.

But look at Don Stone's and Don Holden's moonlit scenes in chapter five (pages 78 and 74) and notice there is no sharp image of the moon on water—only broken streaks of light. And think about driving on a rainy night and seeing the taillights from cars ahead of you reflected in the wet pavement. Instead of sharp reflections, you observe wobbly streaks. What's going on? Let's look at the sketch on page 63, bottom. If the water's surface in *a* were perfectly smooth, you'd see a perfectly round reflection of the moon, and if the wet street in *b* were smooth, the taillights' reflections would be round. But rarely are such surfaces smooth.

Most water surfaces have countless ripples, caused by the wind or by passing boats or other disturbances. The result is a sort of corrugated mirror. Instead of a single, flat "mirror" surface, we have literally millions of small, irregular shiny surfaces. Each little wavelet becomes a mirror and each small mirror is tilted at a slightly different angle from the others. At any given moment, many of these wavelet-mirrors between an observer and the moon will be at the right tilt to catch a bit of moonlight and reflect it toward the observer. In fact you'll often notice stray flecks of reflected moonlight to the right or left of the main path of light—those bits of light are reflected by ran-

**Reflections With Bouquet**
Phil Metzger
Watercolor on Strathmore illustration board
30″ × 40″

Reflections on smooth, flat surfaces are fairly sharp and retain the same basic shapes (but inverted) as the objects being reflected. Reflections in curved surfaces generally are distorted and may be different in both size and shape from the object being reflected. Note the walnuts and their smaller reflections in the silver bowls.

dom wavelets that happen to be properly positioned for an instant to bounce a light ray toward you.

The same phenomenon is happening in the street scene, where instead of wavelets we have many tiny, rounded "mirrors" in the form of gravel or bits of concrete coated with water and oil. Like the wavelets, the coated bumps in the roadway reflect light in a scattered way.

An important attribute of a fuzzy reflection is that it's always *longer* than a sharp reflection of that same object would be. Almost anytime you see trees reflected across a lake, the water will be rippled and you'll notice that the reflections stretch far across the lake toward you. There are mini-mirrors along the light path from the object to your eye, and some of these minimirrors may be positioned to bring reflections all the way across the lake.

(a)        (b)

**Coating of rainwater and oil**

**Pieces of gravel or concrete**

### Curved Reflecting Surfaces.

Look again at *1957 Cadillac* and notice the distorted reflections in the automobile's curved surfaces. Similarly, in *Reflections With Bouquet* the images of the walnuts in the convex outer surfaces of the silver bowls are distorted, smaller than the actual walnuts. If the walnuts were *inside* the bowls, their reflections in the bowls' concave inside surfaces would again be distorted, this time *larger* than life. Reflections in curved surfaces offer lots of surprises, such as double images, inverted images and elongated images, all depending on the shape of the reflecting surface and the position of the observer. Although such images are predictable according to the laws of optics, they are not always what you

might expect. When you're painting from a model, of course, all that's necessary is to paint what you see. Trust your eye. But if you're painting from memory, you may easily be fooled. The best way to figure out any reflection (if you're after realism) is to set up a model and observe.

**Nightfall—Harris Beach**
Peter G. Holbrook
Oil and acrylic on paper
31″ × 40″

Since the sun has set, there is no single, strong light path along the water. Instead the entire water surface acts as a mirror, reflecting the light from the sky. The distant water acts as one fairly uniform mirror, while the nearer, shallower water is more broken and its many mini-mirrors reflect bits of light. Notice that the brilliance of the water surface is enhanced by the surrounding or adjacent dark strips of land.

## Refractions

When light passes through a substance such as glass or water before reaching your eye, the image you see may be distorted in a variety of ways. Such distortions are apparent in Shirley Porter's still life *Stems and Stripes*, demonstrated on pages 68-69.

**What Is Refraction?** Refraction is the bending of a light ray as it passes at an angle from one substance (such as air) into another of different density (such as glass or water). The illustration below shows what happens when light passes from air through a slab of glass and then back into air.

Light travels more slowly in a dense substance, such as glass, than in a lighter substance, such as air. When the light beam strikes the surface of the first glass perpendicularly, the beam is slowed down but its direction is not changed. However, when the beam strikes the second glass at an angle it does change direction, and where the beam emerges from the glass back into the air, it's deflected again. To get a feel for this action, think of the beam as a solid rod with a blunt end. The part of the beam that first strikes the slanted glass immediately slows down but the part that has not yet reached the glass is still traveling fast. The result is a sort of cartwheeling effect as the beam becomes deflected and changes direction. It's as though one of the front brakes in your car grabs and makes the car lurch in that direction.

You've probably noticed that a straight stick thrust into water seems to bend where it enters the water. (Stick a pencil into a bowl of water and watch it "bend.") The reason for the illusion is that light from the submerged part of the object changes direction when it breaks free from the dense water into the less dense air, exactly the behavior just discussed. When you see anything submerged (provided you're not also submerged) you're not seeing it at its true location (unless you're looking straight down at it) as shown in the sketch below right.

Sometimes, because of combinations of materials, and especially because of varying thicknesses of materials, you see light whose source is hard to determine. Refractions most often come into play when painting still subjects involving glass and fluids. Although you can paint strange and beautiful refractions without knowing their causes, it's intellectually more satisfying to know what's going on.

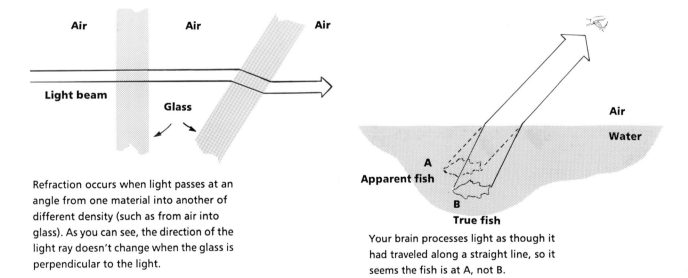

Refraction occurs when light passes at an angle from one material into another of different density (such as from air into glass). As you can see, the direction of the light ray doesn't change when the glass is perpendicular to the light.

Your brain processes light as though it had traveled along a straight line, so it seems the fish is at A, not B.

## Cobalt and Cranberry Glass
Michael J. Weber
Watercolor
24" × 36"

Refractions occur when light passes obliquely from one medium to another. Notice the distortions that occur as light from the large blue vase passes through the ribbed red vase. There are similar distortions with the other glass containers — a discontinuity, for example, in the tablecloth as seen through the rightmost red container.

**Water Light #20**
Linda L. Stevens
Transparent watercolor on Arches 300-lb. rough paper
29½" × 42"
Collection of National Medical Oxygen Company, Orange, California.
Gold Medal of Honor, Allied Artists of America, 1982.

Stevens painted this picture following an early morning walk along a California beach. The night before, the tide had washed large quantities of mica onto the beach and the light made the sand appear to be "made of gold." Painting later from slides, she handled the reflections and refractions by using many transparent overlays of color.

**Painting Clear Glass.** How do you paint something essentially colorless, such as clear glass? Instead of painting the glass, paint what you see *reflected* and *refracted* by the glass and what is *around* the glass.

In Shirley Porter's demonstration (on the next two pages) and in Susanna Spann's *Southern Hospitality* (below), the clear glass objects are visually defined by edges and by what you see *in, through* and *around* the objects. In Spann's painting, the bowl is essentially what's left after painting everything else (negative painting). It would be intriguing to try tracking each piece of refracted color you see in a subject such as this, but if that drives you crazy, you can be content in knowing that you only need to paint what you see before you to have an effective result.

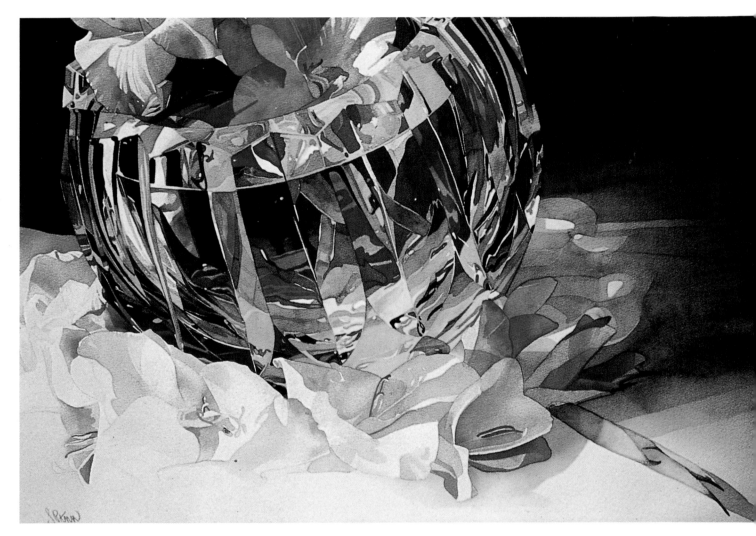

**Southern Hospitality**
Susanna Spann
Transparent watercolor on Arches 300-lb. paper
32" × 52"
Collection of David and Pierrette Bailey, Atlanta, Georgia.

After arranging her bowl of gladioli, with a dark burgundy cloth as a backdrop for dramatic effect, Spann photographed the setup. She then drew her design in pencil on heavy watercolor paper, working from photographs and the actual still life. She painted with the paper lying flat, neither stretched nor fastened to anything. As she used no masking, it was important to preplan where the white or near-white areas would go. She made the lights sing out by placing darks next to them — her rich darks are built up with as many as twenty layers of paint, each applied over a previously dried layer. Spann says her large paintings call for a lot of patience and time — in this case, about one hundred hours of painting time.

### Demonstration ▪ Shirley Porter

# Painting Refractions and Reflections in Glass

What interested Porter in this still life was all the "action" in the glass bowls and the glass spheres. Notice, for example, the discontinuity between the parts of stems in and out of the water; refraction prevents you from seeing the submerged stem in its true position. The submerged parts of stems look thicker than those in air, again because of refraction. Cloth stripes seen through the various objects run in crazy directions and images become inverted, as in the larger glass sphere. It's not necessary to account scientifically for these weird goings-on, but it's comforting to have at least a general idea of what's happening. What really counts, of course, is to observe and paint.

**Stems and Stripes**
Shirley Porter
Watercolor on Arches 300-lb. cold-press paper
30" × 22"
Collection of Judith A. Nicely, Akron, Ohio.

### Step 1
Porter first does a fairly detailed drawing on her watercolor paper. She decides to build up the painting in transparent layers, so she begins with two transparent colors, new gamboge yellow and Antwerp blue.

### Step 2
She introduces Winsor red in varying strengths over some of the yellows, and yellow over some of the blue areas to produce greens. She begins paying attention to detail.

**Step 3**
Porter continues painting details using the same set of colors, and lays in a dark background using glazes of Antwerp blue and Winsor red. Now she begins thinking more about balancing values and colors.

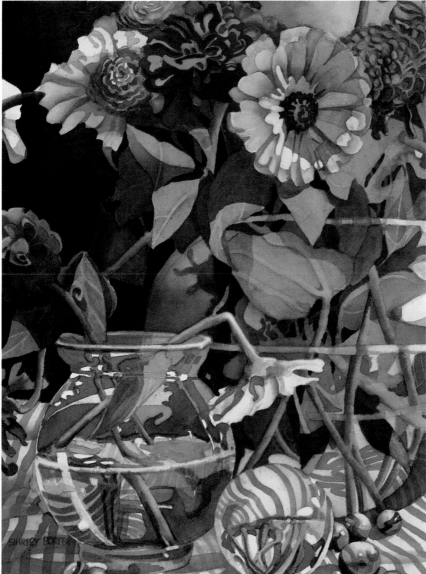

**Step 4**
She finishes by using Antwerp blue in many areas to provide more value contrasts and to unify the painting. She darkens the lower right curve of the large bowl to help balance the dark in the upper left.

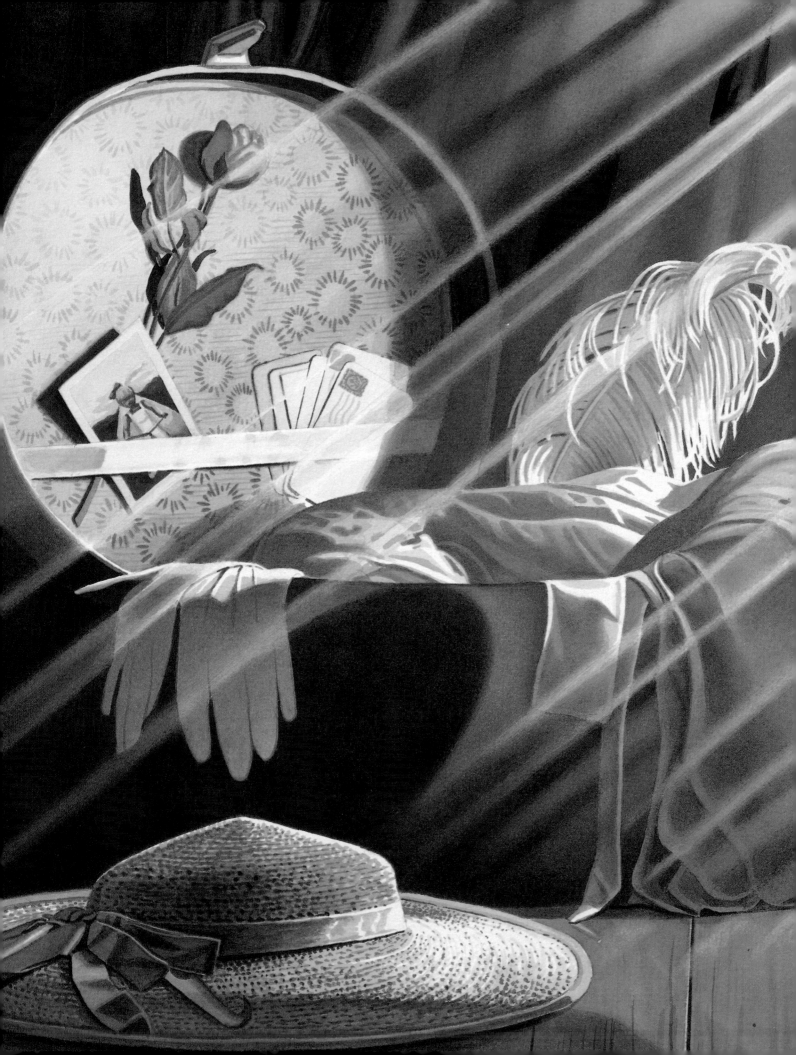

# THE ROLE OF
# LIGHT
# IN PAINTING

# Chapter Five

# Capturing Time and Place

Like photographers, painters make "snapshots" of particular times and places. To signal *what* time and place, they fill their snapshots with clues. Some are obvious: snow on the ground, palm trees on the horizon, rust-red rock formations in the desert. There is a more subtle clue—the kind of light you paint.

Think of your favorite time of day and your favorite place. One of mine would be early evening in the Maryland countryside, when the light is golden and the shadows are long. To me, that's a special, peaceful scene, without the activity and noise of midday in the city, and that time and place seem defined by light.

There is no formula that tells you what kind of light goes with a particular time or place—there couldn't be, because there are too many variables. Seven P.M. in New England is not 7:00 P.M. in Florida, and certainly winter in New England is not winter in Florida. But for a given locale, which you signal by your choice of flora, fauna, architecture, costume and so on, the light reliably follows certain patterns throughout the day and night and during the seasons. You come to understand those patterns only by experiencing those days and nights and seasons.

## Time of Day

In his alkyd painting *Seven PM* (title page), Edward Gordon catches the lovely stillness of a spring evening. The low sun, far off to the right, renders the white porch face in the golden tones that we associate with the light of either morning or evening. Think how different the mood of this painting might be without the golden light on the white porch. The quiet mood is further enhanced by the stark features in the painting: a beautifully graded sky; long, flat land shapes sculpted in shadow by the low light; and severe, unornamented lines in the building. Notice that the gold of the evening light washes over everything, giving even the "green" nearby fields a warm look.

The same kind of light often accompanies the early morning, as well. Let's jump ahead (or back) about twelve hours and look at some paintings depicting *morning* light. In *Florida River* (bottom), Neil Adamson uses some of the same devices just discussed in Gordon's painting. He counts on an overall warm glow, a smoothly graded sky and long flat shapes to bring off the quiet morning mood.

In *Marshland Glow*, demonstrated on pages 76-77, Robert Frank sets the stage for his pastel painting by choosing a warm-colored pastel paper. The amber paper will show through in the final stage of the painting to help define the morning light. Like Gordon's *Seven PM*, this picture has a warm glow made more intense by a contrasting cool sky, and again we see the use of long horizontal shapes; horizontals generally suggest calm, or quiet, while verticals or diagonals often imply action.

Donald Holden takes us back to nighttime in his watercolor *Night at Gull Pond I* (below). He focuses on the light streaming from the sky area to the water, and dramatizes the light by keeping the land shapes stark and simple, with just enough detail for identification and interest. Working in a different medium, oil, Don Stone demonstrates those same principles in *Making Ready*, on pages 78-79.

**Night at Gull Pond I**
Donald Holden
Watercolor
7¼" × 10¾"
Collection of The Ogunquit Museum of American Art, Ogunquit, Maine.

In this scene, Holden decided to omit the moon, which he felt was "corny and distracting," and instead painted the *effects* of moonlight—stark, silhouetted shapes; strong value contrasts; limited color range. Says Holden, "A moonlit landscape is lighter than you might expect, so I painted the rocky shapes with dark color, let them dry, and washed them down with clear water to make the color lighter and more transparent. While the paper was still wet from this 'bath.' I painted the lights and darks in the sky and water."

**Florida River**
Neil H. Adamson
Acrylic watercolor
13" × 22"

Adamson was drawn to paint this tranquil scene even though he feared it was "something fit for a calendar." The time was about 7:00 A.M. on a November day near Sarasota, Florida. While he watched this peaceful scene, a sandhill crane flew by and that settled matters: He had to paint it.

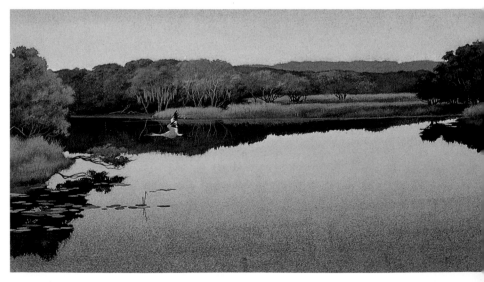

# Painting Glowing Light With Alkyds

Edward Gordon chooses alkyds because he seeks paints that dry slower than acrylics but more quickly than oils. Alkyds can be used in a variety of ways — thin or impasto, smoothly finished or rough. Here is the approach Gordon uses to achieve jewel-like results in his glowing, light-filled paintings.

*Paint:* The binder is a material called alkyd resin. Compatible with oil paints, alkyds are cleaned up with paint thinner or turpentine. A product called Liquin is used as a thinner and for glazing and varnishing. Alkyds dry overnight, allowing a new coat the next day.

*Support:* Any surface suitable for oil painting is suitable for alkyds. Gordon uses ¼-inch Masonite hardboard panels. He applies five or more coats of acrylic gesso to the textured side of this hardboard, and usually three coats to the smooth side. He sands the five-coat side with a drywall sanding screen until it's perfectly flat and eggshell smooth. He paints this surface with three or four coats (one per day) of thin alkyd light gray paint, sanding with 600-grit paper between coats.

*Brushes:* Any type of brush may be used, depending on whether you aim for a smooth, delicate finish or a more vigorous, textured result. For much of his work, Gordon uses synthetic sable brushes, which have bounce yet are soft enough for subtle blending. When painting a large area that requires smooth blending (such as the sky in *Seven PM*) he patiently stipples with round bristle brushes that he continually

wipes on a rag to keep them dry. As the paint on the panel begins to set, a dry brush helps in achieving a smooth, even finish.

*The Drawing:* Gordon first does a detailed pencil drawing on Mylar drafting film. He transfers the drawing to the panel by inserting Sally's graphite paper between the Mylar and the panel and carefully tracing over the drawing with an empty, fine ballpoint pen.

*Painting:* To achieve the light glow in his work, Gordon builds up his paintings in thin, translucent layers. One thin coat of paint does not cover well, but with each successive coat he adjusts color and values. Darkest and lightest areas usually require three coats to cover, while middle values may require two. A bit of Liquin added to a paint mixture increases the paint's translucence and makes it more workable. After each layer of paint dries, Gordon builds up even more translucence by coating the entire painting with Liquin, diluted to a workable consistency with mineral spirits. When dry, the Liquin surface is sanded with 600-grit paper. Often he applies several coats of Liquin, followed by sanding, before proceeding to the next layer of paint.

*Finish:* Gordon covers the finished painting with several coats of diluted Liquin. The number of coats and the degree of dilution must be determined by testing — sometimes too much Liquin will dull the bright areas of the painting. While each coat is drying, the painting lies flat under a cover to limit the amount of dust that can fall into

the wet surface. With firm pressure, he sands each layer of dried Liquin using 600-grit paper wrapped around a 2″ × 9″ piece of polystyrene, which provides a firm support but is not hard enough to damage the painting's surface. Sanding without such a support will create an uneven, dented surface.

After the final coat of Liquin, Gordon sands lightly with 1200-grit paper to remove dust. Then he varnishes the painting by pouring Synvar, a clear synthetic picture varnish, directly from the bottle. Using no brush, he spreads the varnish by tipping the panel back and forth until it's evenly covered. Finally, he lays the painting flat under a dust cover for twenty-four hours to dry. Should he need to repaint some area of the painting, Gordon can remove the varnish by rubbing the entire painting with mineral spirits. This will not harm the underlying Liquin or paint.

## Demonstration ■ Robert Frank
# Painting Morning Light in Pastel

Not every morning is tranquil, of course, but we like to associate that feeling with morning. It's a peaceful time of day before all hell breaks loose! Frank uses some familiar techniques to depict his quiet scene: a gently graded sky, warm light and long, flat shapes. To set the tone for this marsh scene with its early morning light, he chooses an amber-colored Canson Mi-Teintes pastel paper.

**Marshland Glow**
Robert Frank
Pastel on paper
17″ × 21″

### Step 1
The light source is from the right at a low angle. Frank lays in dark masses of land and foliage, choosing a dark violet for its richness and for the deep, warm shadow it suggests.

### Step 2
A broken layer of blue-green pastel moderates and breaks up the dark violet to create texture representing grasses and other foliage. The blue-green pulls together the foreground and background and begins to suggest color reflected from the sky.

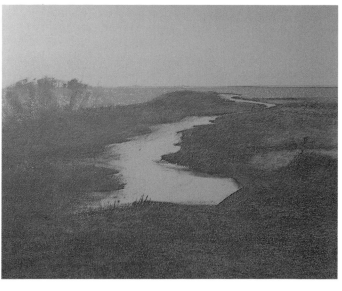

### Step 3
Tones of green and gold ochre add texture and establish the local colors of the ground areas. During this step, Frank pays close attention to texture, shapes and edges. All three levels of color—paper color, underpainting and overpainting—now combine to attain the glow of reflected sky light on ground foliage.

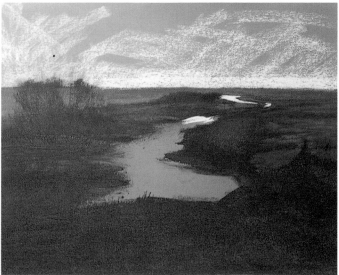

**Step 4**

He applies light blue to the sky and water, and refines the shape of the water area. The composition is strengthened by Frank's extending the water off to the left, thus avoiding a too-centered position for the water shape.

**Step 5**

Frank adds the yellow glow of sky color and corresponding yellow reflection in the water. He also adds warm highlights to the ground area, which has two sources of light: the reflected sky and the strong direct sunlight that skims the surface. He makes the distant ground area, closer to the light source, lighter and warmer than the foreground. He finishes with some final blending of sky and water, along with additional touches of light on the ground areas.

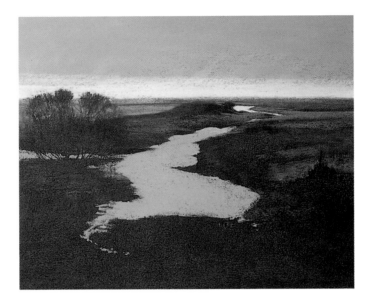

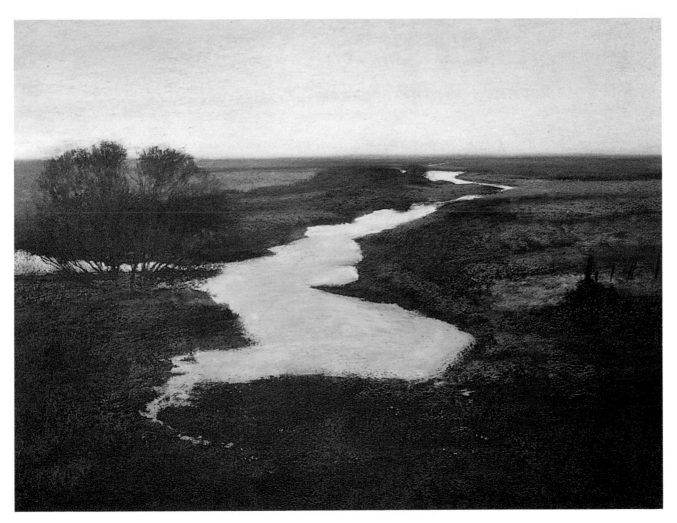

**Demonstration ■ Don Stone**
# Painting Moonlight in Oils

Stone demonstrates the importance of correct value relationships and simplicity of detail in a moonlit scene. Working on stretched Belgian linen, he first gets rid of the glaring white surface by staining it with ivory black diluted with mineral spirits. This grayed surface immediately sets the tone for subdued light. The staining provides a neutral gray against which all other values can be judged. Having established a midtone as a point of reference, he concentrates on establishing the important values in the painting. He limits himself in the early stages to a few large, important shapes (sky, upright plane and flat plane) and a few distinct values, paying little attention to detail. In the final stage, a range of beautifully coordinated lower values says "night" while a glow in the sky and on the water's surface, along with a few well-placed highlights, says "moonlight."

**Making Ready**
Don Stone
Oil on canvas
10″ × 14″

### Step 1
Working on a canvas first stained a warm, neutral gray, Stone quickly establishes important shapes and values. He begins with the darkest areas: the wharf, the schooners and their reflections, and the masts. Then he establishes mid-values with a warm wash for the distant shore and for the seine boats and the shadows in the schooners' sails. For values lighter than the stained canvas, such as the light parts of the sail, seine boats and wharf, he wipes out the stain with mineral spirits. At this stage everything is kept thinly painted and without detail.

### Step 2
With the darks established, Stone next paints in the all-important sky value. If too light or too dark, it would change the whole effect of light in the painting. He uses the same basic colors (white, lemon yellow, Thalo blue, cadmium red) to paint the water's surface, lowering the value in areas away from the light source and heightening the values nearer the light source. To establish the moon's light on the distant water, he uses a heavy impasto of white and a little lemon yellow.

**Step 3**

With the mood now established, he works all over the canvas, still maintaining big, simple shapes, adjusting values and color so that they relate well to one another without unnecessary detail.

**Step 4**

Finally, he adds a few details, such as the schooners' masts, figures, the orange rails of the seine boats, and their red waterlines. He heightens the distant moonlight on the water with more impasto, and adds spots of light for the small lamps on the wharf and the lights on the distant land.

## The Seasons

As the seasons change, so does the light. While seasonal change is minimal in equatorial or polar regions, anywhere else there is plenty to keep the landscape painter from being bored.

Wherever you live and work, you should constantly sketch or photograph seasonal changes around you. Just as important as these conscious acts, however, is your unconscious storing-up of information. When you confront the easel, you pull bits and pieces from memory as well as from sketch pads and photo files, as John Boatright did in his painting, *Golden Pastureland*, below. Boatright started with a piece of Mississippi landscape. He had stopped his car on a drive through the country to photograph some cows. When he turned to go back to his car, "Bingo! There was a picture on my right." Back in his studio he decided to make the cloudless sky more exciting, so he borrowed some Arizona clouds from his slide file, and added them to his pasture scene.

**Golden Pastureland**
John Boatright
Alkyd on linen canvas
28" × 42"
Courtesy of Capricorn Galleries, Bethesda, Maryland.

This painting combines a bit of Mississippi farmland and an Arizona summer sky. Boatright accumulates slides of sky and cloud conditions, often calling on them to enliven a scene. He loves the light of late afternoon for its dramatic possibilities.

What sparks this picture is the bright sunlit strip across the center of the picture contrasting sharply with the muted, shadowed foreground and the dark, distant tree line.

While the golden light in the pasture helps identify Boatright's piece as a late-summer scene, another clue lies in the way the green trees are painted. Throughout the temperate zone, the greens of trees and other plants change from a pale, cool green in the spring to a darker, warmer, redder green in midsummer. Compare the spring greens in Michael Wheeler's *New Growth—Bullskin* (above) with the mature, dark greens in *Pastureland*. The former is washed by cool light, the latter by warm light. The difference between the two light effects is important to note if you would have your painting believably depict one season or the other.

**New Growth—Bullskin**
Michael Wheeler
Acrylic on canvas
30" × 36"
Collection of Dr. Dan McFadden, London, Kentucky.

This spring scene is bathed by a cool, green light typical of that time of year in temperate regions. By late summer, pale, cool greens give way to warmer, redder greens, like those in Boatright's trees. Cool versus warm greens are an important indicator of season in landscape painting. Wheeler begins his paintings with large, loose approximations of his final colors; he does not underpaint in complementary colors, as some artists do, nor does he do a detailed underpainting.

Moving into fall, a temperate landscape is likely to be bathed in warm light even on the coldest of days. It's a good time for the landscape painter of detailed realism because instead of huge masses of greens, the skeletal forms of things begin to be revealed. Notice the glint of warm light on distant tree trunks in Wheeler's *Stream Bed—Laurel County* (below), and the intricate latticework of bared trunks and branches in the nearer middle-ground.

**Stream Bed—Laurel County**
Michael Wheeler
Acrylic on canvas
24½″ × 19½″
Collection of A. Gordon Thomas, Charlotte, North Carolina.

By fall, masses of greens give way to a huge range of warm colors and light begins to penetrate sparse foliage to expose the intricate skeletons of trees and other plants. Wheeler relies mostly on a single tool— a no. 4 Sabeline brush—for most of his detail. He feels he can concentrate better on his paintings by keeping his tools simple and few.

When winter hits, a typical day in northern climes might present you with the cold light of Warren Allin's *Connecticut Winter* (above). In this painting, Allin uses a thin, dark tree line to contrast with otherwise bright surroundings—just the reverse of Boatright's use of a narrow band of brightness to contrast with muted surroundings. In both cases, strong value contrasts are central to the effectiveness of the pictures.

Both Boatright and Allin used a little skulduggery in their paintings. Just as Boatright combined Arizona clouds with Mississippi land, Allin painted *Connecticut Winter* in Maryland in the summer, with only photographs, notes and vivid memories to place him in Connecticut. It's not always possible to combine such elements and have them work together—a palm tree in my Maryland backyard won't work, no matter what! But years of observation will tell an intelligent artist what light and other elements make sense. As for the

general question, is it "legal" to combine pieces of information to compose a scene, of course the answer is a resounding *yes!* What counts, as always, is the *result*, not how you got there.

**Connecticut Winter**
Warren Allin
Oil on canvas
24″ × 48″
Courtesy of Images International Art Gallery, Bethesda, Maryland.

The sky and snow here are both brilliant, one practically mirroring the other. When you view a scene full of brilliant light, the glare makes your pupils constrict to limit the amount of light flooding into your eyes. The result is that you don't see much detail in darker forms, especially if they are in the distance. They tend to appear flat, almost silhouetted.

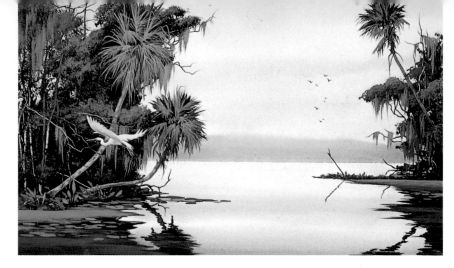

## Place

Much has been written about the light in places such as Arles, in southern France—many painters, including Vincent van Gogh, made a beeline for that region to paint its unique light. Here we'll confine ourselves to examples in regions of the United States.

**The Southeast.** Can Neil Adamson's *Southern Palms* at the opening of this chapter be mistaken for any place other than the extreme Southeast? Everything in it says "Florida"—the palms and other flora, the white egret, and certainly the warm, brilliant light that floods this late-morning Everglades scene. In *Dusk: Seeking Shelter* (right, top), he captures the late evening Florida light.

**The Southwest.** While the Southeast may be thought of as dominated by warm, intense light, that light is tempered by masses of cool, green foliage. In the Southwest there is a similar light intensity, but here marked by the hot reds, yellows and oranges of bare rock and clay, and the browns of dry brush and wood.

In Warren Taylor's unusual two-panel work, *Juárez* (page 85, top), an early evening light traces a transition from stark, warm desert colors to cool, exotic green-blue mountain shades. The many objects in the painting share a central, horizontal light that unifies the jumble of shapes representing the chaotic, informal rhythms of this scrambled and active city.

On page 85 (center), Peter G. Holbrook decided to make a familiar Grand Canyon scene special by concentrating on a single formation—a floating triangle of sunset light—and stretching the colors to the brink of credibility. The dry air at 7,000 feet accounts for color intensity, but it also provides little atmospheric perspective, so Holbrook had to rely on other means

of conveying a sense of distance. He painted extreme detail subtly diminishing toward invisibility. Bringing this off required attention to edges: sharp at focal points and on shadows cast a short distance; and softer in the peripheral areas and in shadows cast a long distance or shadows turning a rounded corner.

**Dusk: Seeking Shelter**
Neil H. Adamson
Acrylic on Crescent illustration board
10″ × 15″

Adamson is known for his brilliant treatments of Florida subjects. He has developed a keen eye for the rich colors and varied textures brought out by the strong Florida light.

**Juárez**
Warren Taylor
Watercolor
40" × 120"
Collection of Mr. and Mrs. Martin Hanan.

Once the artist's imagination is freed from the tyranny of realism, anything becomes possible in a painting. Taylor indulges his imagination by using a jumble of objects to represent a wide sweep of land from hot desert on the left to cool mountains on the right. Crammed between the two extremes is Ciudad Juárez on the northern Mexican border, painted here in varying states of repair and disrepair.

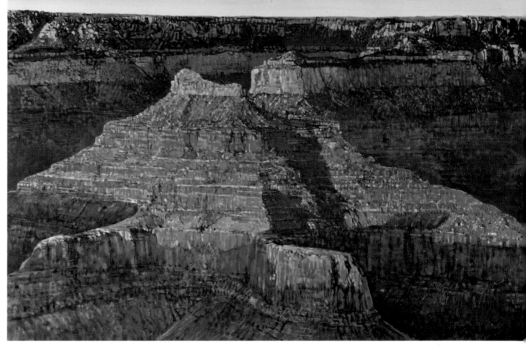

**Evening—Mohave Point**
Peter G. Holbrook
Acrylic and oil on paper
27" × 40"

**(Left)**
**Pinnacles Beyond**
Harold E. Larsen
Watercolor collage
40" × 30"

In this painting of Monument Valley, Arizona, Larsen describes the fading light in the high desert. Toward evening, shadows grow long and rock colors that were washed to pastel under the hot midday sun now catch the long, low rays of light and begin to glow. The graded wash of the sky adds drama and mystery.

Rembrandt supposedly advised, "If you would paint an apple, first *be* an apple!" Holbrook might add, " . . . and if you would paint a rock, first *be* a rock!" He emphasizes the importance of knowing the subject you're painting. In this scene, for example, smooth, vertical surfaces reflect much of the low, late sunlight striking at nearly right angles. Horizontal surfaces, rough with vegetation and only skimmed by the sunlight, reflect more muted greens and ochres. "This information can be vague in the film record," says Holbrook, "so knowing the place helps you to paint what you can barely see."

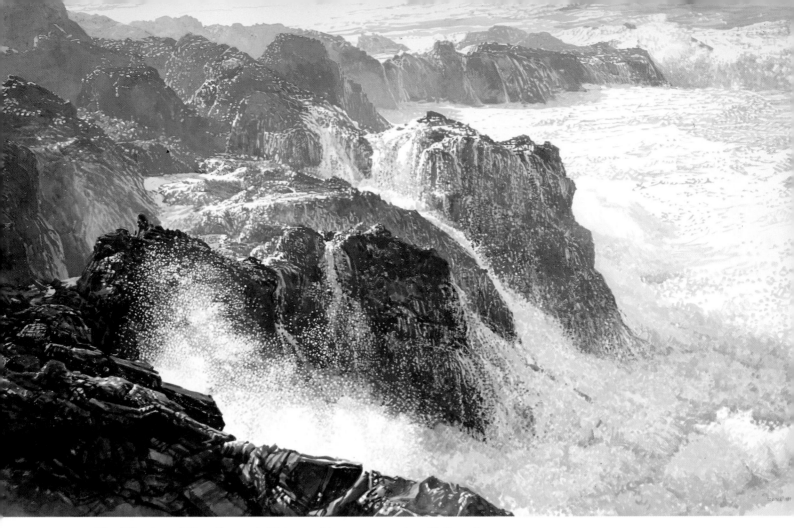

**The West and Northwest.** This huge area I'm lumping together provides a broad range of subject matter and light that stimulates a great variety of interpretation among the artists who work there. Here are three artists whose working methods and whose *way of seeing* could hardly be more divergent.

At dusk along the northern California coastline, Peter G. Holbrook photographed a scene he later painted and called *North Headlands* (above). In this scene the air is full of spray from a raging sea. The color of the local rocks is cool, compared to those we've seen in the Southwest, and the entire feel of the painting is cool and crisp. Although the color in the most distant line of rocks is warm compared to those close to the viewer—an apparent reversal of the usual "rules" of aerial perspective—there is still a perfect sense of distance because the farthest shapes are flattened and less detailed than the closer ones. From this vantage point, Holbrook was facing almost into the late sun.

Compare the finely detailed, "realistic" approach of Holbrook with the patterned, impressionistic look of Mary Sweet. In *North Headlands*, Holbrook delights in capturing all the textures and the color and value nuances of nature, including countless flecks of light that make his painting sparkle. In *Maroon Bells Above Crater Lake* (page 87, top) and in her demonstration painting (pages 88-89), Sweet works entirely in flat, emphatic color patches that *suggest* light, form and detail.

Settling somewhere between these two approaches is the abstract work of Jan Dorer (page 87, bottom). Although she paints little of the precise detail that Holbrook loves, neither does she paint in Sweet's hard-edged color patterns. Rather, she uses a mix of hard and soft edges and both smooth and textured paint.

**North Headlands**
Peter G. Holbrook
Acrylic on Arches 140-lb paper
40″ × 62″

Holbrook shot this scene from a precarious perch. He usually works from many slides of a scene and from his memories and feelings about the place. The slides are his own because, he says, "The few attempts I have made to paint from a photo I didn't take were abject failures."

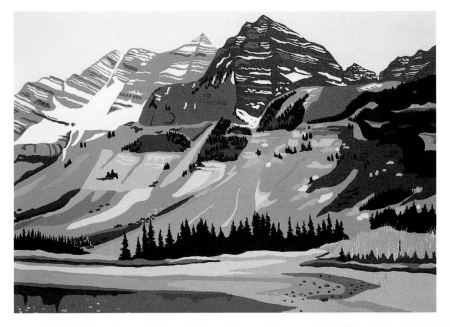

**Maroon Bells Above Crater Lake**
Mary Sweet
Acrylic on paper
22" × 30"

By playing colors against one another, Sweet conveys a sense of depth and reality. Yet her painting holds its own as simply a beautiful tapestry of flat colors. This painting resulted from an October hike along a trail between Maroon Lake and Crater Lake in Colorado. Sweet says, "The atmosphere was more like late fall—the last gasp of autumn before winter. I tried to catch that diffused light by graying the autumn colors and using colors close in value."

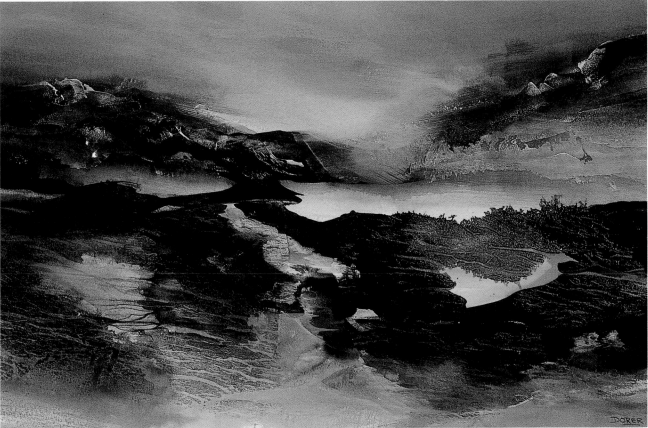

**Alaska Series #4**
Jan Dorer
Acrylic and watercolor on Crescent board
32" × 40"
Collection of Michael and Trinda Johnston, Hudson, Ohio.

Dorer painted a series of abstracts after spending some weeks in Alaska viewing and photographing mountains, rivers and glaciers from a small, low-flying plane, occasionally landing on a glacier for a better view. Her paintings are combinations of opaque acrylic and transparent watercolor passages, which allow her wide latitude in producing light effects. In many areas, such as the suggested mountains in the background, she built up texture with white acrylic and a painting knife and then glazed over these areas with watercolor, sponging off some of the watercolor to let the white show through.

### Demonstration ▪ Mary Sweet

# Painting Light Patterns in the West

Sweet loves the land, especially the mountains, canyons and rivers of the West. She paints "the nuances of the land as revealed by the effects of light upon it — the floating patterns of cloud shadows on vast desert spaces, the sharp blue shadows that contrast with sunlight on rock walls, the mysterious crevices cut by flash-flooded streams into narrow canyons and illuminated by light streaming through dark notches." She seeks out places that people have not yet ruined and captures them vividly on paper.

**Morning Stroll, Bryce Canyon**
Mary Sweet
Acrylic on paper
30" × 22"

### Step 1
After sketching only main shapes lightly in pencil, Sweet begins at the top and works down the page. Each area takes at least two coats of paint to get the smooth, flat finish she likes. She "draws in" details with paint as she proceeds.

### Step 2
She uses strong reds to catch the dramatic sunlight on red sandstone. "The first coat of paint in a new area is for the color," Sweet says. "If I am satisfied, I coat it again with that color. If not, I change it until I am satisfied. Reds and oranges are transparent and take a number of coats. Details are often lighter or darker versions of the given color, so it is convenient to put them in as I go before that paint dries up on my palette."

### Step 3
Sweet adds more detail and more middle ground. She experiments as she moves through the painting, placing splotches of color where she thinks she might like them, such as the warm yellow at lower right.

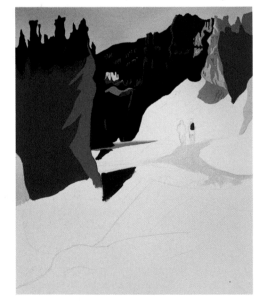

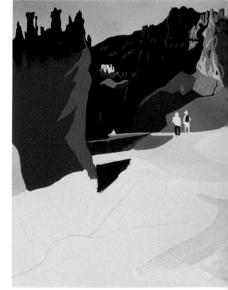

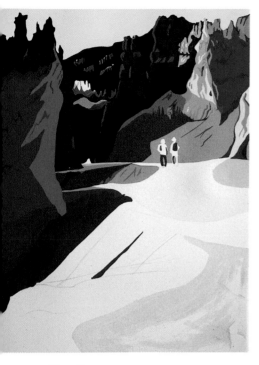

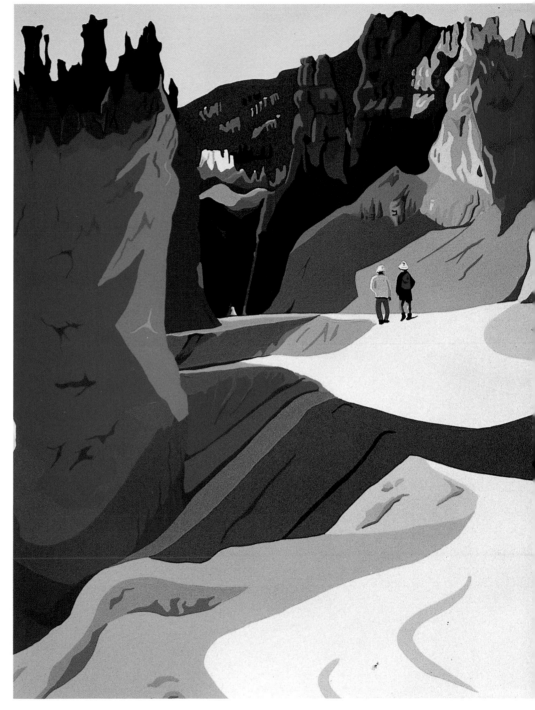

## Step 4

In stark contrast to painters who under-paint an entire paper or canvas at the out-set, Sweet finishes each area as she works from top to bottom, relating each new area to what she has already painted. She has found that waiting until the end to add details does not work for her. Because some areas have a lot going on in them, she paints other areas relatively large and simple for contrast and relief.

## Step 5

When the painting is "finished," Sweet looks at it from a distance, generally for the first time. She is satisfied with an area not just on the basis of the colors and how they "feel," but by whether or not she has captured the illusion of sun and shadow patterns on rock walls, effects she has ob-served and studied carefully many times.

**The East.** Where there are extremes of light (and correspondingly, extremes of color hue and intensity), those can be used in a painting to help define a geographical area. There is no point, however, in pushing that idea to absurdity. In the region I'm calling the East (including the East, the Midwest and the Northeast) light is more subdued than elsewhere and is of less help in defining locale.

That huge temperate region lacks the brilliantly lit green of Florida, the hot, red intensity of the Southwest and the clear, cold blue of Alaska. Instead we find a range of more moderately lit landscapes that fit somewhere between those extremes. In such areas there must be less reliance on light and more on identifying features such as flora, fauna, costume and architecture.

**The Piedmont**
Lou Messa
Acrylic
16" × 38"

Late afternoon light casts long shadows across fields and trees near the foothills of Virginia's Blue Ridge Mountains. In a painting with so much dark shadow, it's important to keep the shadows luminous—there should be plenty happening in the shadowed areas. A common mistake is to think of shadows as opaque darks where nothing much is visible. On the contrary, if you look intently into a shadowed area, you often see more color and detail than you see if you look into a brightly lit area, where details may be lost in the glare.

**Wash Day, Monhegan**
Don Stone
Oil on canvas
10" × 14"

The bright light on the face of this house is repeated in the laundry blowing on the clothesline and in the lively greens of the foreground. The deeply shadowed sides of the house provide a striking contrast to the sunlit sides, but there is plenty of reflected light within those shadows. The dark northeast evergreens provide a suitably ragged backdrop for the more severe lines of the house.

**Dogwood Shadow**
Michael Wheeler
Acrylic on canvas
24" × 20"
Collection of Robert Mason, Charlotte,
North Carolina.

Wheeler catches the crisp, clean atmosphere at the edge of some Kentucky woods. As he does so often in his paintings, he makes full use of the many cast shadows to help describe the texture of the ground beneath the snow. He also looks for shadow patterns that are in themselves engaging shapes. Notice that in a backlit scene (assuming reasonably flat ground) cast shadows of vertical objects point back toward the light source.

# Chapter Six
# Suggesting Distance

Have you ever looked at a picture you've just finished and wondered why it looks as flat as the canvas it's painted on? Some of my students used to protest that that was the way they *wanted* it to look! Occasionally I believed them. It's perfectly legitimate, after all, to treat the surface of a painting as just that—a *surface*—and to ignore or even avoid the possibilities of making it seem three-dimensional.

For a great many artists, though, the illusion of distance, or depth, is critical to their work. Renaissance artists, who were often remarkably good scientific scholars, devoted a lot of effort to developing the techniques we now take for granted in creating the illusion of three dimensions on a two-dimensional surface. All these techniques together are called *perspective*.

You can "experience" perspective by visiting a mountaintop, as I did recently in Virginia's Blue Ridge, or look out your apartment window over a broad cityscape. You'll see objects (be they mountains or skyscrapers) become cooler and less distinct as they march off into the distance; things get progressively smaller as they recede; edges blur; details become lost. Many of these phenomena are the result of aerial perspective, the tricks light plays on us; others are the result of normal interpretation of things by the human eye and brain. Whatever the reasons for seeing things as we do, all these experiences can be represented in paint.

**a**

**b**

## Aerial Perspective

We all know that objects seen at a distance look different from similar objects seen up close—not only in size but in color and value. The reason colors and values seem different from a distance is that you're looking through a sort of veil to see them, and the farther away you are, the thicker the veil. The veil, of course, is the layer of air between you and the object. It contains water droplets and impurities such as automobile exhaust, smoke and dust particles. This air acts as a filter, cutting down on the total *amount* of light reaching your eye and also allowing certain *wavelengths* of light to pass through

(a) Barns with the same local color, but looking different because of aerial perspective; (b) Mountains showing a similar effect.

**Shenandoah**
Phil Metzger
Acrylic on canvas, 36" × 48"
Collection of Dorsey Hammond.

A number of techniques move the eye back into this scene: (1) Warm colors up front, cools in the rear; (2) paler values in the distance; (3) more detail close than in the distance; (4) size variations, such as in the fence posts; (5) linear perspective (the road). Everything except a sign with an arrow pointing the way!

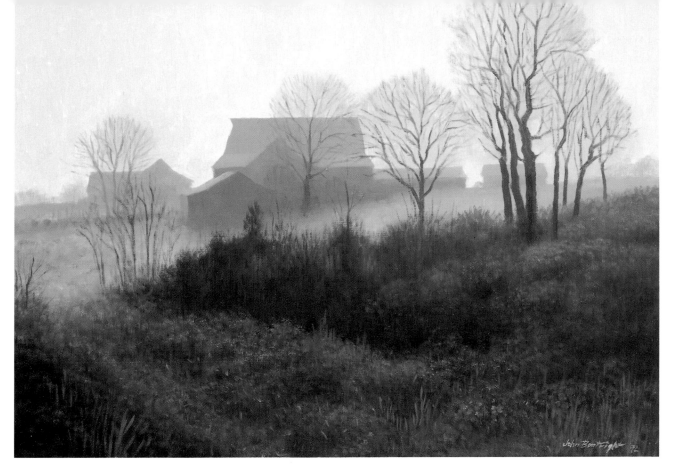

while blocking others. The cool colors (such as blues) get through most easily, while a lot of the warm colors (such as reds) are blocked or scattered. Together, these two phenomena—color and value change over distance—are called *aerial perspective.*

The implications of aerial perspective for the painter are clear: If you want something to appear more distant in your picture, cool its color and lighten its value. There are all kinds of exceptions to this, but most of the time it's an effective painting technique. In Peter G. Holbrook's *Bryce—Natural Bridge* (page 92), there is a steady progression from warm-colored rock formations near the viewer to cooler and paler formations in the middle distance to a flat, blue-gray range farthest away. Similarly, in *Shenandoah* (page 94, bottom), colors go from warm in the foreground to cool in the distance. One observer of this picture commented that the farthest little mountain couldn't *possibly* be that vibrant a blue. While it not only *could* be, but *was* that blue, I might have chosen to make it so because I liked it that way.

We generally paint close objects warmer and distant objects cooler and paler because that's the way we usually see them in nature. There are plenty of instances, however, where the scheme is reversed. There may be "cool" ice or snow in the foreground, and a mass of warm foliage or rock formations in the distance. If that's the case, paint them that way and rely on other techniques (see next sections) for suggesting distance.

A special example of aerial perspective is illustrated in John Boatright's *Morning Fog* (above). Shrouded by fog or mist, the most distant objects disappear completely and the farthest objects you can see are those normally considered to be in the middle distance (e.g., Boatright's barns). There is a sort of collapsing of distance. In a dense, foggy scene, the range of sight would be even less than shown here. To treat such scenes convincingly, it's necessary to paint those middle-ground objects flatter, less detailed, than you might paint them on a clearer day, and of course gray their colors dramatically.

**Morning Fog**
John Boatright
Oil on canvas
18″ × 24″
Courtesy Albers Fine Art Gallery,
Memphis, Tennessee.

Scenes in mist or fog are treated as two-stage paintings—foreground and middle ground. The denser the fog, the more visual distance is lost. Detail is obscured and the most distant visible objects will appear relatively flat.

**Demonstration ▪ Dennis Frings**

# Aerial Perspective

Frings was trained as a watercolorist, but found that medium too limiting. "I have always enjoyed the luminosity of oil painting," he says, "and at the same time desired the fluidity of watercolor. Monoprinting gave me the best of both worlds." He now "underpaints" using printing techniques with thin, fluid paint, and finishes with layers of oil to build up the luminous qualities he likes.

**Klieber's Woods**
Dennis Frings
Oil and oil pastel on paper
26" × 36"

**Step 1**
Frings's first step is done on a large-format, flat-bed lithographic printing press. He applies thin oil paint (similar to a watercolor wash) to a printing plate with a 12-inch brayer (roller), and dabs on Varsol thinner to break up the paint surface. Varsol is responsible for the "hole" in the upper left, which will be used later to give the effect of sunlight hitting the leaves of foreground trees. He prints his paper using this plate.

**Step 2**
Frings mixes six color groups (two greens, two mauves, a brown and a gray) in large puddles. The paint is fairly oily. He applies the paint briskly, using wadded-up newspaper as his "brush." At this stage he's looking for lots of texture. He leaves some areas of the first layer untouched so that pale distant areas contrast with the busy foreground textures, creating a sense of distance.

**Step 3**
Frings paints tree trunks, branches and water areas, using brushes and a 1-inch brayer. Because there is so much texture already in the painting, Frings decides not to complicate the water area with reflections. Its quiet simplicity nicely echoes the background mist. He applies final touches with oil pastel—just bits of color in quick, small strokes here and there to pick up some color highlights.

## Linear Perspective

Although linear perspective has a great deal to do with creating an illusion of depth in a picture, it is not primarily a function of light, and will be covered here only in an introductory way. (For a full treatment of linear perspective, see *Perspective Without Pain* by Phil Metzger, North Light Books.)

Linear perspective is the use of converging lines to suggest depth. If you take two lines that you know are parallel, such as the edges of a road, and make them meet, you introduce a feeling of "distance." The road in *Shenandoah* (page 94) and the one in Wheeler's *Horse Creek Backroad* (page 99) are examples of the use of converging lines to help lead the eye deep into a picture.

## Overlap

A simple way to suggest distance is to place one object in front of another. The overlapping instantly shows that one is closer to the observer than the other. A special case of overlap is illustrated by Edward Gordon's inside-out paintings, such as *April* (page 98). The abrupt switch from indoor objects to vistas seen through a window or doorway never fails to establish depth.

## Size and Space Variation

Hold out your thumb and compare its length to that of something else in the room—maybe the dog snoozing in the corner. Your thumb isn't really bigger than the dog (is it?) but it seems to be because of the different distances the two objects are from your eye. You can put this illusion to work for you in a picture by depicting objects of known size gradually diminishing in apparent size as they retreat farther into the picture. The fence posts in *Shen-*

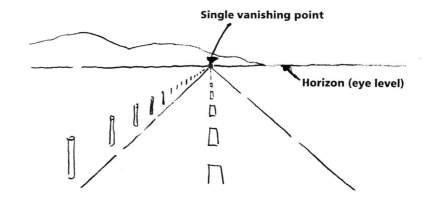

An example of linear perspective: You know the edges of the road are parallel, but forcing them to meet at a point (called the "vanishing point") on the horizon gives the impression the road is stretching off into the distance. This is *one-point* linear perspective.

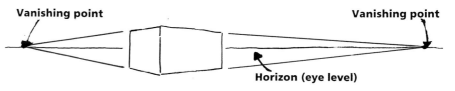

The parallel, horizontal edges of this box, if extended, seem to converge at two different points on the horizon. This is an example of *two-point* linear perspective.

There is no way of knowing whether one of these objects is farther away than the other, unless they overlap.

*andoah* are an example. You *know* they're all the same size, but the eye sees they are painted in progressively decreasing sizes and the brain automatically concludes that the size difference is because of differences in distance. The same is true of the *spaces* between objects. The fence posts can be assumed to be evenly spaced, but they are shown with ever-decreasing spaces between them. Much about painting is fooling the senses.

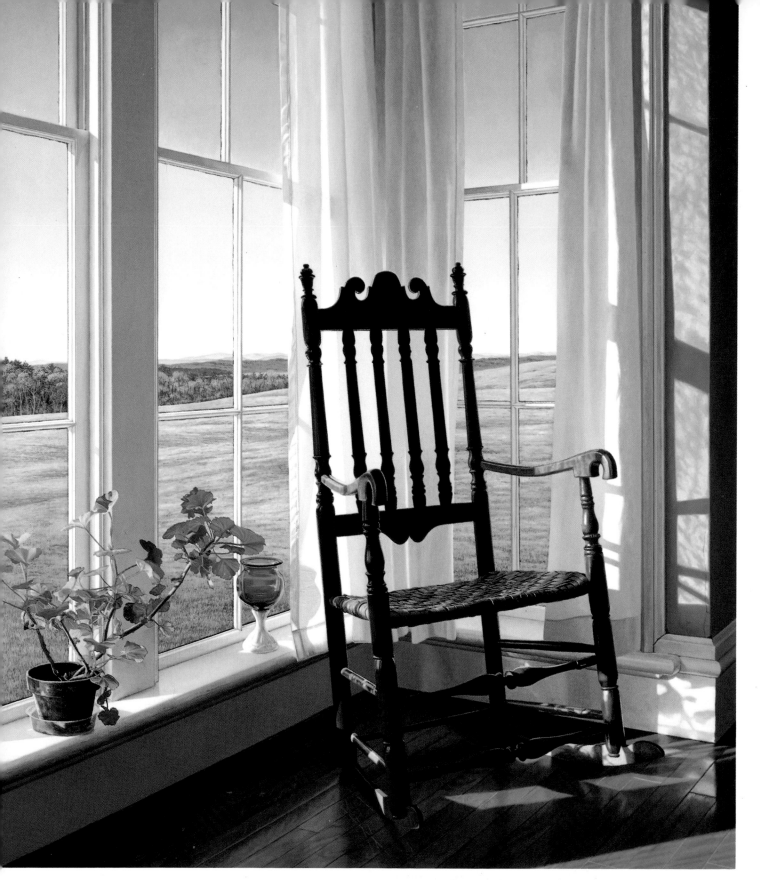

**April**
Edward Gordon
Alkyd on panel
23″ × 20″
Courtesy of Capricorn Galleries, Bethesda,
Maryland.

There is an immediacy about all the ob-
jects in the room; they are obviously close
to the viewer. Everything outside auto-
matically seems distant because of the
separating action of the windows.

## Detail and Edges

Because we see less detail and less distinct edges in distant objects, it's reasonable to paint them that way. *Horse Creek Backroad* (right) puts this idea to good use. The tree foliage becomes gradually less distinct as we move back into the picture, both in terms of sharpness of edges and amount of detail. Holbrook's *Bryce—Natural Bridge* (page 92) is another good example. The amount of detail in the rock ledges diminishes in stages, as does the sharpness of all edges. In this painting, Holbrook says, the day was so clear that there was less sense of distance than usual, so he added haze to separate foreground from background shapes. "Sometimes," he says, "you have to take liberties with the weather to give credibility to an incredible place."

## Modeling

You also need to express "distance" on a more modest scale when painting, say, objects in a still life. The distance I have in mind is the thickness of an object, and often the key to representing this is modeling. In the illustration below, the apple drawn in silhouette has little hint of depth. But when modeled with shadow, it becomes three-dimensional. The same, of course, is true of objects on a grander scale, such as hills and buildings.

**Horse Creek Backroad**
Michael Wheeler
Acrylic
20" × 16"
Collection of Carol Ciganko, Brecksville, Ohio.

Wheeler wanted the hazy light to convey the feeling of midday heat and humidity. He uses several techniques here to achieve a sense of distance: (1) aerial perspective, achieved partly by using white and orange washes, or glazes, (2) linear perspective, (3) diminishing detail, (4) edges that soften in the distance, and (5) overlap.

## Sudden Value Changes

Often a jolt in values can signal a jump in distances, as in *Late Zinnias* (right) and *Twilight Memories* (below). Such value jumps are really just a special case of aerial perspective with middle grounds missing—there is only foreground and background. As is nearly always the case, there are other techniques at work here, such as overlap and color change.

**Late Zinnias**
Michael Wheeler
Acrylic
24" × 20"
Collection of Sandra Hylant, Toledo, Ohio.

The abrupt change in value between the shadowed zinnias and the sunlit backdrop creates the illusion of a jump in distance. The illusion is further emphasized by (1) overlap, (2) aerial perspective, and (3) diminished detail in the distant woods.

**Twilight Memories**
Robert E. Frank
Pastel on paper
7" × 10"

Aerial perspective and a sudden jump in values combine to suggest distance.

## Combining Techniques

Nature doesn't always cooperate. Sometimes, as in Holbrook's *Bryce* painting, conditions are so clear that aerial perspective is minimal. In other cases, objects are not arranged for overlap or for effective linear perspective or for size variation. But having a bag of tricks allows you to invent or manipulate conditions to suit your needs. There is no particular merit in painting something just as it is— there's only merit in painting it as you *want* it to be.

**Farmyard**
Phil Metzger
Pencil on Morilla Bristol paper
8½″ × 12″

Distance is suggested by (1) aerial perspective in the trees and hill at left, (2) linear perspective in the road and buildings, (3) diminishing sizes in the fence posts, (4) overlapping of the large tree, shed and barn, and (5) value changes.

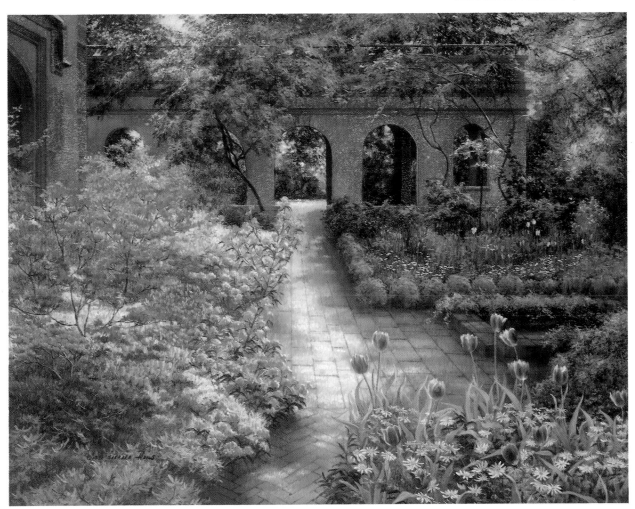

**Courtyard Garden**
Barbara Hails
Pastel on ground glass board
24″ × 30″

Depth is achieved by (1) linear perspective in the walkway and arches, (2) aerial perspective (warm colors forward, cools in the distance), (3) more detail in the foreground than in the distance, and (4) bits of sky showing through the foliage.

# Chapter Seven
# Defining Structure

**Still Life on a Blue Table**
Jane Lund
Pastel on paper
25¾″ × 27⅝″

The modeling and cast shadows are soft and delicate because there are two light sources, a north window and studio light. The two sources account for the double cast shadows.

"Okay, John," says the teacher, "let's see how your tree came out." He looks at John's flat painting and, being a kindly fellow, tries to think how to break the news.

"How's it look?" asks John.

"Well, let's put it this way. Do you feel you could wrap your arms around this tree?"

"What?"

"Have you painted the impression there may be something hidden *behind* the tree?"

"Huh?"

So much for *form*. Trying a different line, the teacher asks: "Do you feel you could get your fingernails under a piece of bark and pry it loose?"

"Bark? It's only paint!"

So much for *texture*.

"Hmmmmm! John, have you ever climbed a tree?"

"Nah! I lived in Brooklyn. Only sissies climbed trees!"

The teacher decided to give up teaching courses in representational painting. The following week he began a course in abstract expressionism.

## Form

The form of an object is its physical presence—its bulk, shape and size. Form is revealed mostly by three factors: shadows, color change and surface shapes.

**Shadows.** If John's tree had shown nothing more than careful attention to light and shadow, it might have looked round instead of flat. There are at least three ways in which shadow can help define form:

1. The *shape* of the shadow clearly signals the shape of the surface over which it falls. Remove all the shadow from Warren Allin's *Rock Creek* (right, bottom) and you will flatten the terrain.

2. Gradual *value change* in a shadow usually tells you that the shadow is wrapping around some curved surface. In her pastels *Still Life on a Blue Table* (page 102) and *Pregnant Woman* (right), Jane Lund describes many rounded forms by defining subtle value changes with exquisite care.

**Pregnant Woman**
Jane Lund
Pastel
38" × 22½"

"In this self-portrait, depicting volume was of prime concern," Lund says. "I worked from life: a full-length mirror to my left and my easel in front of me. The same light that illuminated the easel also shone on me. The placement of the figure against a dark background, the limited pictorial space, and the intense observation of detail transforms this woman into a still life object. Use of a single light source heightens the volume of the figure and increases the sense of detached observation."

**Rock Creek**
Warren Allin
Oil on panel
11" × 14"
Collection of Mr. and Mrs. William Snape.

Shadows define most of the shapes in this late-afternoon painting. Allin began by covering the panel thinly with blue-gray paint mixed with a fast-drying medium. Before this midtone was dry, he blocked in the dark areas. He pressed suggestions of trees and brush into the tacky surface with the side of a coarse brush loaded with a mixture of paint and gel medium (Weber's Res-n-gel). The dark water came next, a mixture of Thalo blue, burnt umber and gel medium. Last came the sunlit snow, white with a touch of yellow ochre.

In most of her still life paintings, Lund prefers natural light. Working from life rather than photographs, she sometimes covers her studio windows with black plastic to limit the light on the subject to one main source, such as a north window. If necessary for stronger definition, she places a lamp near the studio window to supplement the natural light. At other times, as in *Pregnant Woman*, she uses a single light source to emphasize volume.

3. Sharp *value contrasts* between lighted and shadowed objects often emphasize the shapes of the objects. The shape of the table in Lund's still life is shown by the value differences between adjacent edges of the tabletop. In *Everything in White* (right, top), Joyce Pike places large areas of shadow behind white petals, instantly defining the petals' shapes.

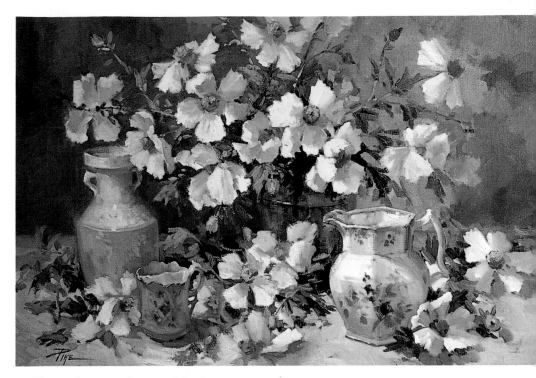

These three attributes of shadows—shape, gradual value change and sharp value contrast—rarely occur alone. Usually two, or all three, are present. In each of the paintings just mentioned, more than one kind of shadow is present, and in this pencil sketch of a tree (below), all three are illustrated.

**Everything in White**
Joyce Pike
Oil on canvas
24″ × 36″

A continuous pattern of shadow holds all the elements of this painting together. In addition to the obvious cast shadow on the backdrop, there are delicate shadows on some of the petals, helping to give them form. Shadow in the foliage behind the flowers provides contrast with the white blooms and modeling on the pitcher and vases gives them form. Here, as in many paintings, *shadow* helps inject a third dimension into an otherwise two-dimensional arrangement of colors.

There are several "kinds" of shadows and they all help define structure: (1) Cast shadow and (2) modeling indicate roundness of the trunk; (3) backdrop shadow helps show the shapes of forward objects; (4) thin, sharp cast shadows tell of cracks, holes and overlapping surfaces, such as scaling bark; (5) cast shadow of a cuff of bark shows the roundness and direction of the branch; and (6) thin cast shadows where two surfaces join help define the shapes of those surfaces.

## Demonstration ▪ Michael P. Rocco
# Defining Form With Light and Shadow

Rocco chooses a simple but powerful subject. "To me," he says, "this painting is more than a pictorial representation of a doorway in a church, it is symbolic of one's faith." His beautiful demonstration captures not only the form-giving property of light and shadow, but intense reflections and reverse shadows as well.

**A Church in Spain**
Michael P. Rocco
Watercolor
20½" × 14"

### Step 1
Because this will be an intricate painting, Rocco makes a precise drawing on vellum from a 35mm slide. He transfers only the major shapes to his watercolor paper to keep the paper as clean as possible, and traces off more details as he needs them. After wetting the area of the wall around the doorway, he paints into this the glowing color of the wall and the soft reverse shadows at the upper right (shadows thrown upward by light reflected from the floor).

### Step 2
He begins to define the intricate molding around the doors, capturing reflected light and shadows. Here he is concentrating more on establishing values than on architectural detail.

### Step 3
This is the most important step, establishing the drama of the composition. The strong reflected light on the door moldings has to be held back so as not to conflict with the stronger light from an unseen window at the left. Says Rocco, "The feeling I get from the painting at this point is like a crescendo in a musical piece. I know it is what I wanted." He continues to define the arch in the upper left corner, an important element that keeps the viewer's focus on the doorway and keeps attention from wandering out the left side of the painting.

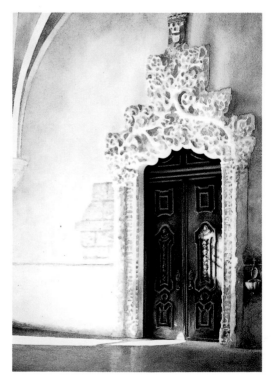

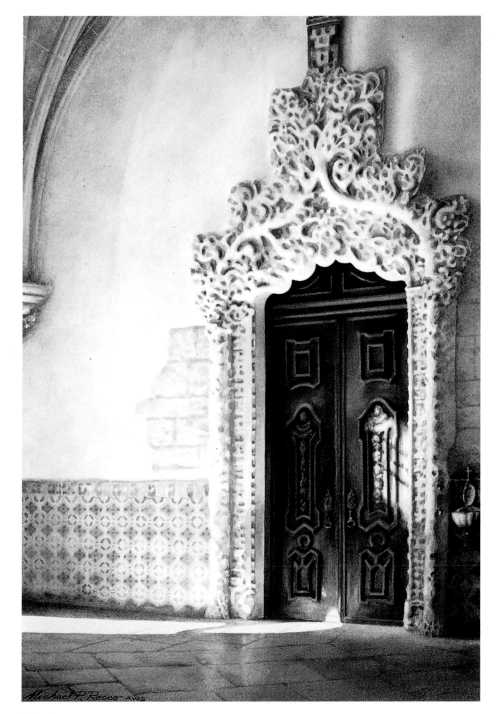

## Step 4

He paints the wall tiles carefully, but avoids being mechanically precise. He adds details in the floor and deepens some shadows. Rocco paints the holy water container at the right, wrapping up the spiritual story of the painting. Without it, he feels, you would not know you were in a church and the symbolism would be lost.

**Color Change.** Color change usually goes hand-in-hand with value change. In Lund's rounded forms, for example, each form curving around into deeper shadow also exhibits subtle color variation as well. The color often becomes deeper and cooler. In *Tree and Meadow* (right), I relied on value and color change to show the roundness of the trunks and branches, deepening the color on their shadowed sides. For most of the modeling I painted the area opaquely from light on the sunny side to fairly dark on the shadowed side, and then deepened the shadows further by overlaying successive washes of bluish acrylic. I've always felt that shadows painted by glazing are more transparent and convincing than those painted directly and opaquely. Mr. van Gogh might disagree.

Working in pastel and exhibiting her trademark vibrant color, Sally Strand delicately models the forms in *White Bucket* (right, bottom) with shadow and color. She picks a few spots where the value is highest (left shoulder, right knee, white bucket) and uses varying degrees of shadow to push everything else back and to give objects their form. Because warm colors tend to advance and cools recede, she increases the effectiveness of the transitions by keeping the light areas warm in color and the shadows cool.

**Surface Shapes.** Obviously, the shapes of an object's visible surfaces contribute to its general form. In Rocco's *Millwright's Shop* (page 109), the elliptical top of the pot tells you the pot is round and the individual rectangular surfaces in the sill signal that these are bricks. Linear perspective comes into play as well. Notice, for example, the extra solidity given the brick sill because the joints between the bricks converge and aim at some vanishing point outside the window.

**Tree and Meadow**
Phil Metzger
Acrylic on canvas
24″ × 30″
Collection of Scott Douglas Metzger, Frederick, Maryland.

I was concerned with three light-related aspects of this scene: (1) the roundness of the trunks and branches, (2) textures, and (3) a sense of distance between the tree and the meadow behind it. While the modeling and texture were achieved primarily by painting shadows, the illusion of distance between the tree and the meadow depends on the abrupt value and color change between them.

**White Bucket**
Sally Strand
Pastel on paper
38″ × 22″
Courtesy of J. Cacciola Galleries.

Asked whether she sees all that color in shadows, Strand says she heightens what she sees to get the vibrant effects she likes. Colorful shadows serve not only to enliven the entire picture surface, but also to model the forms, providing a striking three-dimensionality. Compare Strand's lively, hatched pastel strokes with the controlled, invisible strokes of Jane Lund.

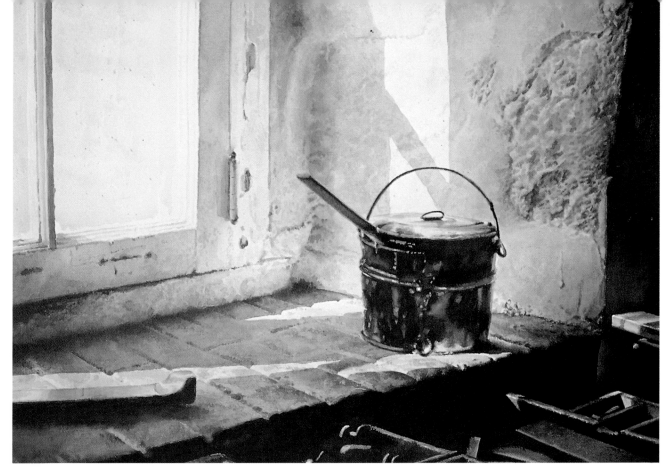

## Texture

Texture is the visual or tactile nature — the "feel" — of a surface. The notion of texture may be applied to any surface: Skin or bark may be smooth or wrinkled, cloth may be silky or coarse, and even water may be calm or choppy. The depiction of an object realistically in paint is not complete until its surface texture is captured.

Most illusions of texture rely on the creation of side-by-side patches that are different in value or color, or both. Objects around you illustrate the point: A "solid"-colored carpet, for instance, looks textured because it has lots of tiny indentations in shadow that contrast sharply with the surface areas that are in light; a multicolored carpet exhibits the same light-and-shadow texture, but its adjacent patches of contrasting colors add to the textured look. Textures are usually the result of both value and color variations, and there are several techniques for establishing these variations on canvas or paper: painting patches, scumbling, painting on textured grounds, lifting and spraying.

**Painting Patches.** When relatively small patches of color or patches of value are painted alongside one another, the abrupt transition from color to color or from value to value creates an illusion of unevenness. In his demonstration painting, *Blue Fish Cove* (on the next two pages), Peter G. Holbrook pays meticulous attention not only to the *form* of each element in the painting, but to the *texture* of each as well, as he paints patches of rock or water surface that vary in color and value. Thanks to his painstaking observation and photography of his subject and careful translation into paint, it's easy to place yourself in this scene and feel both the textured solidity of the rocks and the agitated surface of the water. All this as a result of painting in the dark! (See the sidebar on page 112.)

**Millwright's Shop**
Michael P. Rocco
Watercolor
18″ × 24″

Both direct and reflected light model the forms and bring out the textures in this scene. The crumbly texture at the right is the result of numerous pits, which catch bits of shadow, contrasting with the smooth texture of the pot and the moderate textures of the sill and wood window frame. Rocco's procedure was to lay in the general light areas first, then the planes of the wall and sill, followed by the darks of the foreground and the wall at the right. The cast shadows followed. The broken plaster was done with some drybrushing and careful lifting to soften edges. Rocco arranged shapes, such as the tools at the lower right and the object at the lower left, to nudge the eye into the painting. The dark strip along the right and bottom edges provides dramatic value contrast and helps focus on the lighted center of the painting.

**Demonstration ■ Peter G. Holbrook**

# Painting Form and Texture

**Blue Fish Cove**
Peter G. Holbrook
Acrylic on Arches
140-lb. cold-press
paper
40" × 58"
Collection of Dave
Tonhemacher, South
Pasadena, California.

## Step 1

Holbrook soaks the watercolor paper, clamps its edges in a framework of wooden lattice strips secured by wing nuts, and allows the paper to dry drum-tight. In the darkened studio (see sidebar, page 112) he projects his slide onto the watercolor paper and masks off the paper in the proportions he wants, using wide masking tape. Over the masking tape he places narrower black photo tape that provides both a border visible in dim light and a black reference for dark values in the painting. By the light of the projected image he begins painting the darkest values with mixtures of ultramarine blue and burnt sienna.

## Step 2

Still operating in a darkened room and still placing darks first, Holbrook works his way "forward" in the painting. He modifies the dark gray mixture with siennas for warmth, Thalo blue or Payne's gray for coolness, added water for lightness, and tube-strength titanium white to stiffen a mixture for dry-brush work and softer edges. He uses the largest brush capable of rendering a given scale of detail. His objective is to swiftly capture the patterns of light and shade.

The unfinished water area with its loose initial brushstrokes contrasts with the more finished rocks, where Holbrook has intensified his color and has sharpened focus and contrast with transparent shadows and opaque highlights.

## Step 3

With light and dark values established, he adds thin layers of local color. In the water, for example, a transparent blue in some areas indicates reflected sky. Accurate color is less important to Holbrook at this stage than accurate values.

## Step 4

Now with the studio lights on, Holbrook views the slide under various magnifying lenses and lays out a fuller palette, and the painting proceeds along more traditional lines. He refines most areas of the painting, but makes no radical changes, although he considers some: "I debated a long time," says Holbrook, "over whether to delete the bits of sargasso floating in the lower right water—they seemed too busy at one point, but became sufficiently integrated with further darkening of the shadow areas. That great mass of subsurface seaweed creates the calmness of the water and gives this place its special character, so I was glad at last to keep it."

## Step 5

Carefully working all over the picture, Holbrook introduces more color nuances and hardens or softens many edges. He dramatically deepens the shadows in large areas and in smaller cracks and crevices, making forms still bolder and surfaces more tactile. He uses an airbrush without masking to give greater density to some areas without introducing added lines or edges. The elaboration of form, color, texture and focus are all hung on the underlying pattern of light and shadow, and Holbrook takes pains not to contradict or eradicate that pattern. As the painting nears completion he views it under many different kinds of light as well as in reverse in a mirror. Not at all timid at the end, he says: "The last strokes should be at least as bold as the first."

# Painting in the Dark

Peter G. Holbrook's brand of realism begins with carefully observing his subject and shooting slides from several vantage points. He chooses one dominant slide (keeping the others for reference), projects it onto his stretched watercolor paper in a darkened or dimly lit studio, and paints directly on the paper without drawing. Because the projected image, in effect, *is* his drawing, Holbrook expends much effort and care in producing the slide.

Working with light from the projector and from a small lamp illuminating the palette, he paints an area in a fair amount of detail, beginning with the darkest values and working toward the lighter ones. He does not follow the common practice of laying in large masses of color, because to do so would rapidly obscure the projected image. Instead, the initial process is one of reinforcing the projected image. Detail is suggested and may later be eradicated or refined. As he works an area, he frequently holds up a white card to recapture the original projected image. Painting in the dark requires developing a "feel" for the paint in your brush. It also needs some alarm to signal you

to rest your slide before it burns up in the projector.

The objective of painting in the dark is to capture the patterns of light and shade. For many photo-realists this first stage would be done under normal light, painting over a detailed pencil drawing in a sort of paint-by-numbers approach, a method Holbrook avoids because it's tedious and stifling.

"When working in the dark," says Holbrook, "a strange phenomenon takes place. You are in a darkened room listening to the drone of the projector's cooling fan, with your nose in a field of projected light. Shapes begin to lose their identity as discrete objects and appear more like parts of an abstract but unified field. . . . You lose track of exactly what stuff you are recording and where its edges lie, but you become aware of other things, like rhythms that permeate the whole scene. Thinking becomes very right-brain and the application of paint becomes rhythmic and tireless. I hesitate to define what quality this process imparts to the painting, but it is always there when you turn on the lights, and it is always a surprise."

ken strokes of color, producing lively textured effects. An extension of scumbling is the use of tools such as sponges and wads of tissue or newspaper to deposit thick paint over existing layers, as Dennis Frings does in his demonstration in chapter six. In *Sycamores* (page 113, top), I used a small natural sponge to help build up the foliage on the scrub growth as well as throughout the background area. The varied texture of natural sponges is preferable to the uniform texture of synthetic sponges. Be careful. Overuse of a sponge can result in a monotonous, too-busy surface, as some of my earliest paintings emphatically illustrate!

**Painting on Textured Grounds.** Paint may be applied over a textured canvas, paper or other ground to produce effects similar to scumbling. Watercolorists use this method when they whisk the side of a not-too-wet brush over the surface of rough or cold-press papers, so that paint is deposited only on the "hills" and not in the "valleys" of the paper. (In general, "rough" means the paper's surface is heavily textured; "cold-press" paper is only moderately textured; "hot-press" paper is smooth.) Artists working in other media, such as pastel and graphite, often use textured paper to help attain the illusion of texture.

Painters in oil, acrylic and alkyd also may get a running start on the texture they want by painting over roughened grounds. In *Sycamores* I wanted to paint the broken light of an overcast winter day on the brittle trees and scrub growth. To create initial texture I slathered on acrylic gesso with a painting knife and then textured the wet gesso randomly with both the knife and a coarse brush. I carried the texture over the entire canvas, even the sky area, to enhance the "broken light" effect.

**Scumbling.** Paint may be applied roughly, one color or value over another, leaving small patches of the first layer to peek through the broken outer layer. This is called *scumbling,* and its effect is twofold: The patchiness suggests texture, as does the roughness of the paint layer, although the latter effect is usually minor, depending as it does on seeing the painting up

close under raking light. Some scumbling is evident in all but the smoothest paintings—there is some, for example in Holbrook's relatively smooth work. And although historically the term has been applied to oil painting, there is a great deal of what I would call scumbling in Sally Strand's, Robert Frank's and Barbara Hails's pastels; they all build up layers of bro-

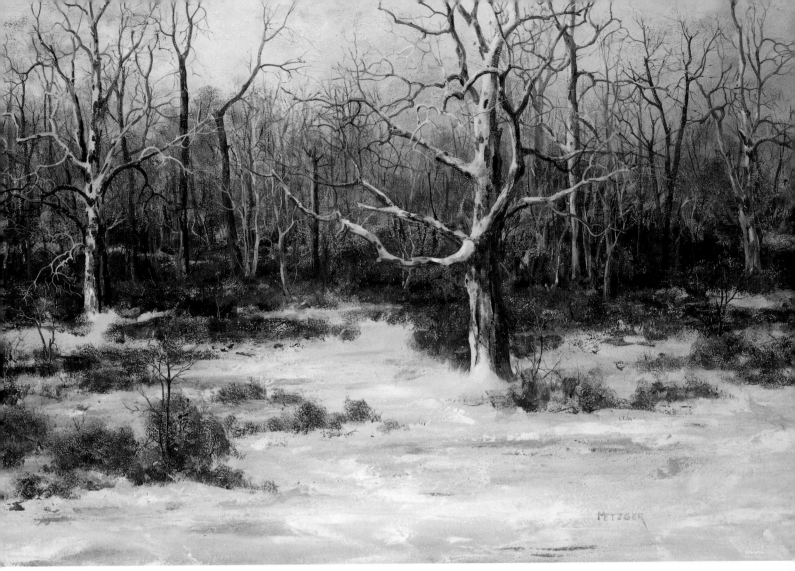

**Sycamores**
Phil Metzger
Acrylic on canvas
36″ × 48″
Collection of Scott Douglas Metzger, Frederick, Maryland.

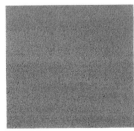

A brushload of paint applied to rough, cold-press and hot-press watercolor papers.

Aiming for a textured surface that would suit the brittle nature of the subject, I added a coat of acrylic gesso to the factory-gessoed canvas, smearing and moving the gesso around with a painting knife and a coarse brush to get as random a texture as possible. This final coat is as much as 1/16 inches thick in places, while in other parts the weave of the canvas shows through.

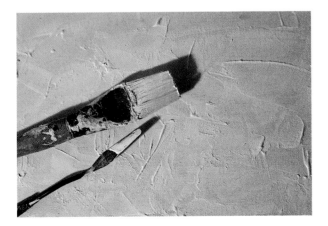

**Lifting.** A favorite technique among watercolorists is to *lift* paint from the paper, thereby exposing earlier layers or the white of the paper itself. Sometimes the lifting is done by scraping through still-wet (fairly thick, not too soupy) paint using a dull object, such as a kitchen bowl-scraper or your fingernail. At other times, dried paint is lifted by gently scrubbing it with a moistened brush or sponge, a wad of tissue, a cotton swab or whatever.

A variation of the scraping method is scratching wet paint with a sharp object, such as a pointed brush handle or a toothpick. In this case, you cut the fibers of the paper and the frayed fibers *attract* paint like a blotter; the paint gathers in the scraped areas and forms sharp, dark (and permanent) lines. These techniques can easily be overdone, resulting in a harsh, hard-edged painting or one that appears overworked or gimmicky.

Lifting is often appropriate in other media, as well. The tools are varied: In a graphite drawing, you might remove a tiny bit of graphite with a point of a kneaded rubber eraser or by scratching with a blade, although you must be careful to avoid dirtying or damaging the picture's surface. You might remove acrylic with sandpaper or a knife. On the facing page, Warren Allin demonstrates how he carves away oil paint to reveal the highlights on a textured old face.

**Spraying.** The paper I used to demonstrate scratching (at right) was hot-press (smooth), yet its surface looks textured. You can easily get this mottled appearance in watercolor or acrylic by gently squirting water droplets into the air above the horizontal painting. Where each droplet hits the damp paint, the water pushes the paint aside a little and a small blotch is

formed. The result varies with the wetness of the paint—if the paint is too wet, it will simply run back into the blotched area and the effect will be lost; if too dry, there may be no effect at all. You must experiment to get the right paint consistency and the right timing.

If you substitute droplets of thinner for water, this technique also works in oil or alkyd. But again, timing and paint consistency are crucial.

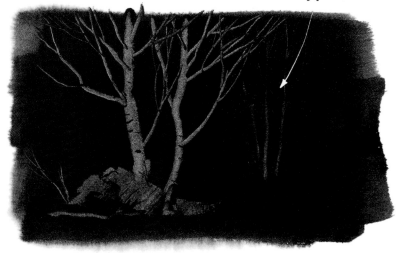

**Scraped into wet paint**

**Lifted from dry paint**

You can achieve textures in watercolor by lifting paint from the surface in a variety of ways. Here, thickish watercolor was scraped aside using a plastic kitchen bowl-scraper; this took about fifteen seconds.

The softer trees at the right were gently scrubbed out with a damp bristle brush after the paint had dried. Similar results can be achieved in other media.

These dark lines are the result of firmly marking the paper, while the paint is still wet, with the pointed end of a brush handle. The cut paper fibers suck up paint like a blotter. The overall blotchy texture was attained by squirting droplets of water into the still-damp paint.

## Demonstration ■ Warren Allin
# Achieving Texture in Oils by Lifting

Allin stumbled onto this method while confronting a failed painting. As it was not going well, he smeared the paint (which had been mixed with a damar varnish medium) in a thin layer over the surface of the panel and began poking at it with his fingers and brushes. After a few hours of this therapy,

he found he had "released" from the darkish paint a man's head and hand. It was easy to manipulate the paint and create textures by dragging, pressing, stippling or scraping with anything that would make a mark. Allin's early use of damar to achieve the appropriate paint consistency gave way to modern tube

gels that are similar in consistency to tube paints and are not as destructive to brushes. Each manufacturer's gel medium has a different drying time, and different colors also have different drying times (e.g., burnt umber, fast; alizarin, slow), so you must experiment to find suitable combinations.

### Step 1
Allin thins his paint (Van Dyke brown) with a roughly equal amount of gel medium (Grumbacher) and covers the panel fairly thinly, using a 4-inch thick bristle brush. He cautions against using a larger proportion of medium, for it will tend to yellow. He establishes the subject in a loose way by scratching through the surface in some areas with the brush handle and using straight brown pigment in others. For further thinning of the paint other than that provided by the gel medium he uses a turpentine substitute — odorless, to keep peace in the family.

### Step 2
He begins modeling the head by removing paint (using brushes and his fingertips) to establish highlights on areas such as the cheekbone, forehead, nose, lower lip and earlobe. He also lifts a little paint from the cheek at the left of the picture to suggest reflected light. He adds thinned brown madder in areas around the cheek. Areas in shadow are defined using Van Dyke brown with very little medium.

### Step 3
Always keeping in mind the light source, Allin further defines bone and muscle structure. Since he is working from his imagination, not from a model, he is free to experiment. Still working in "wet," movable paint, he easily alters the background, adds the cap, and softly defines the collar, still using a combination of lifting and applying paint. This last stage took much longer than the earlier ones. Total working time for the painting: about sixteen hours.

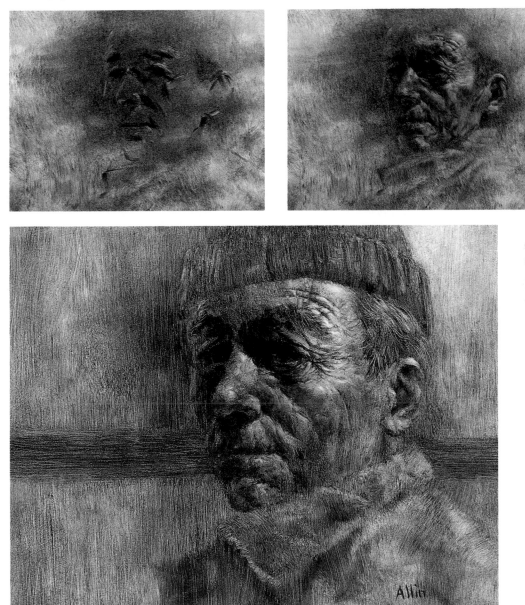

**Fisherman**
Warren Allin
Oil on acrylic-gessoed Masonite
16" × 20"

## Combining Form and Texture

Subjects such as "form" and "texture" are separated in this book only for discussion purposes. In practice, you never find one without the other. Let's look briefly at several quite different paintings in which light and shadow play strong supporting roles in describing *both* form and texture.

In Michael P. Rocco's *Mill-* *wright's Shop*, on page 109, light dances all through the picture, defining the structure of all that it touches. Shadows and color changes invade the crumbly wall at the right, the brick sill, the jumble of tools—everything. Similarly, in Wheeler's *Afternoon Light* (below), light models the roundness of each tree trunk and at the same time uncovers the texture of the bark and the shape and texture of the ground beneath the snow.

In a different sense, light and shadow combine in Adamson's *Everglades Cypress* (page 117, top) to define a sort of mosaic backdrop, texture on a large scale. And in Porter's *Onions* (page 117, bottom), the roundness of the onions and the crispness of their skins are made plausible by recording in paint nuances of both color and value.

**Afternoon Light on New Snow**
Michael Wheeler
Acrylic on Masonite
10½″ × 18″
Collection of Charles Luellen.

The broad shape of the terrain is shown by the way shadows drape over the contours; trees are modeled by the darkness wrapping around their shadowed sides. The ground texture is rendered by paying attention to the many adjacent patches of light and dark.

## Everglades Cypress
Neil H. Adamson
Acrylic on illustration board
14" × 18"

Centered on two huge bald cypresses, this painting is a good example of a variety of textures—smooth water, crumbly Spanish moss, spongy green moss, crisp bits of foliage. But in addition to these individual textures, the entire woods backdrop has a "texture" all its own because of the variations in color and value within it.

## Onions
Shirley Porter
Watercolor on Rives BFK printing paper
22" × 29"

The roundness of the onions is described (a) by gentle value changes, (b) by gradual color changes, and (c) by the directions of lines, such as the striations in the skins. Texture is indicated by more abrupt color and value changes—e.g., between a section of skin and the smoother underlying "white" of the onion. Texture is also signalled by the contrast between the light-colored strips of the skin and the sharp, darker grooves separating the strips.

# Chapter Eight
# Creating Mood

**September 21**
Edward Gordon
Alkyd on Masonite
32″ × 24″
Collection of Edward
and Karen Gartner.

Light is used here to
describe a warm,
quiet place indoors,
away from the out-
door chill. The deep
shadows surround-
ing the sunny spot,
along with the old-
fashioned window
and chair, the wood
floor and small-print
wallpaper all help
create a quiet, nos-
talgic mood.

Years ago I painted a watercolor of an old spruce tree in Maine. The colors were pretty much browns and light blue. I looked at it when I was finished and wondered why I had wasted perfectly good paint and paper.

I hate throwing stuff away, so I decided to rework the thing. Trouble was, I didn't know exactly what I disliked about it. (Ever happen to you?) A friend came to the rescue. She asked what sort of mood I was after in the painting.

Mood? Oh, yes, mood. Forgot about that. The fact was, I couldn't answer because I didn't know. I was just working with a tree I liked and throwing paint at the paper, assuming everything would come out okay. I had no mood in mind at the outset and it showed at the finish. I had painted what teacher Edgar Whitney used to call a "thoughtless painting."

I decided to whack away at this pale, lifeless watercolor and convert it into an acrylic with some oomph. I thought of this gnarled old tree as a tough, quiet survivor, and that's the mood I decided to try to paint. This time I was happier with the result, *Blue Mood*, shown in chapter one. I've become convinced that a painting begun with no mood in mind may become a painting with no reason for being.

## The Elements of Mood

Many things affect mood, but certainly light is a dominant element. You know how light affects you and those around you; surely you feel the difference between winter gray and the lightness of springtime, or between a noontime sun and evening shadow. Filmmakers make lots of money playing with the way lighting affects a scene.

The mood of a picture is the feeling it evokes in the viewer. Although here we're most interested in the effects of *light* on mood, let's take a brief look at other picture elements as well, for they all contribute.

1. *Shapes.* Smooth horizontal shapes impart a sense of stability and quiet, while vertical or jagged shapes signal action or energy. Compare a flat lake with a splashing waterfall, or long, flat meadows with abruptly rising cliffs or mountains.

2. *Textures.* Rough or choppy surface textures often signal a mood different from that of a smooth surface. Texture, in this context, means more than the tactile nature of a single object. For instance, there are two rows of books on my bookshelves: One is a jumbled, helter-skelter row of books of uneven sizes and colors; the other is a row of look-alike books with identical bindings. The former has an active, eye-catching "texture," while the latter is smooth and quiet.

3. *Edges.* Often the nature of an edge makes the difference between a quiet and an active mood. Sharp edges tend to be more lively than softer ones.

4. *Hue.* The hue (red, yellow, green, blue, etc.) chosen for a passage can violently alter the mood of that passage. A red sky would simply not suggest moonlight, nor would orange foliage be consistent with a springtime mood.

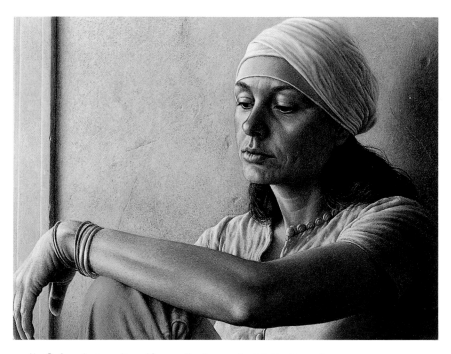

5. *Color intensity.* Also called *saturation,* color intensity is a measure of how *strong* a particular color is. A mass of foliage, for example, may be a dull, muted green or a bright, dazzling green.

6. *Value.* The play of values against one another, regardless of hue, contributes enormously to mood. Strongly contrasting values tend to speak loudly, while closer tones whisper.

7. *Objects.* The things one chooses to paint can themselves affect the mood of the picture. In part, this has to do with the shapes of those objects, as already mentioned, but it also has something to do with the nature of the objects and what kind of feelings they bring forth. Nostalgic paintings of old barns tend to induce a quiet yearning for "the good old days," while a painting of a congested steel-and-glass city scene might easily have the opposite effect.

## Quiet Mood

The term "quiet" includes a range of states and feelings, such as contemplation, sadness, wistfulness, peacefulness, stillness, reverence

**Judith in Reverie**
Robert J. Brawley
Egg tempera on paper
13" × 16"
Collection of Art Institute of Chicago, gift of Richard and Jalane Davidson, Chicago, Illinois.

Soft light and soft-edged, luminous shadows perfectly support this relaxed pose. Imagine how different the mood would be with a sharp, hard-edged light and shadow pattern.

and mystery. Light is arguably the single most important element in establishing such conditions in a painting. In Robert Brawley's *Judith in Reverie* (above), everything about the pose of the painter's wife—the relaxed droop of the hand, the lowered gaze, the relaxed face—says she is lost in thought. But it's the play of soft light that finishes the idea. Imagine this figure in a different kind of light—bright hues, hard-edged shadows—and the spell is broken. Brawley sets up a similar mood in *James* (page 121, top), but here there is an intensity about the char-

acter, rather than the relaxed, far-away lostness of *Judith*. Again light is crucial. By depicting the softly lit character (his friend, James) emerging from a dark, sub-dued background, Brawley estab-lishes a sense of mystery about who this man is and what he has experi-enced.

## Elements of a quiet mood.

Don Stone relies on both light and shapes to set the tone in *Morning Surf* (page 124). The long, flat shapes of the sky and horizon are calm; the rolling wave, despite its obvious action, is kept relatively quiet by making it a long shape without too much value contrast. The warm hues of the sky are echoed in the water and the rocks, making this scene friendly and comfortable. The same scene could have been made brash and threat-ening by replacing the warm sky color with cool, by similarly cooling the rock and water areas, and by introducing some stark value changes within the foaming water.

Lots of darks in a painting will usually guarantee a quiet mood, as in Lou Messa's *Fond Memories* (page 124) and in my *Catoctin* (page 125). When painting such large, relatively dark areas, it's vital that something be going on in those areas. In Messa's picture, for exam-ple, there is plenty of reflected light on hay, posts and walls to keep them interesting and alive. Dark areas are not the only road to a quiet mood. Shirley Porter's *Spec-tre* (page 125) is high-key, but the melting of edges into the back-ground, the bird's stance (note the legs suggested at the bottom of the picture), and the absence of other objects in the picture all help sug-gest an aloneness. There is some-times little separating a quiet from an active mood. If the bird in *Spec-tre* were shown not perched, but flying toward you, there might be a distinct switch of moods.

**James**
Robert J. Brawley
Graphite on paper
24¾″ × 33½″
Collection of Philip Desind, Bethesda, Maryland.

"We are old friends who grew up to-gether," Brawley says. "Jim is now a writer and sea captain. For his portrait I wanted to work essentially in darker mid-tones resonating with rich and moody blacks. This resonance that I sought would be keyed by the contrast of lighter forms. I composed him as I so often saw him, in deep reflection as he held his cup of cof-fee. I chose to show his face half in light, half in dark, creating a Janus-like duality that expressed his intensity and reserved-ness. The cross-lighting brought out the character of his face and history."

**James**
(Detail)

### Demonstration ▪ Linda Stevens
# Painting the Sacredness of Life

Many painters work on more than one level. They produce works that have a straightforward decorative appeal while at the same time they address some favorite personal theme. Linda Stevens's paintings are an example. Her work for many years has had a certain unifying theme, which she describes as "affirmation of the sacredness of life." Her demonstration, *The Seventh Day*, is from her Creation series.

**The Seventh Day**
Linda Stevens
Transparent watercolor and 24 K gold leaf on Arches 300-lb. rough watercolor paper
60″ × 40″
Photography by Gene Ogami.

**Step 1**
Working from several slides of her subject, Stevens draws preliminary sketches in pencil and transfers the final drawing to her watercolor paper. She builds her painting using many overlapping layers. Painting on dry paper, she establishes her first layer with cadmium yellow pale wherever the final result is to be yellow or where yellow will be needed to build another color, such as yellow-green.

**Step 2**
Next she paints cadmium orange over many areas, including some of the yellow sections, and then repeats the process with a third warm color, alizarin crimson. At this stage, some areas are still untouched, some have one layer of paint, some two and some three.

**Step 3**
Stevens continues methodically layering, a single color at a time, now using Winsor green and Winsor blue. The layers of warm and cool colors begin to mix optically.

## Step 4

Now she introduces strong value contrasts using a dull blue-green mixed from Winsor blue, ultramarine blue, alizarin crimson and burnt sienna in various combinations. She applies gold leaf to form the "shen" sign (the circle with a bar underneath at the top of the painting), used in ancient Egypt as the sacred sign for creation. The shapes of the two flamingos repeat the symbol; lotus blossoms symbolize new life. As final touches, Stevens brightens the flamingos and emphasizes the edges of the lotus leaves using alizarin crimson and cadmium orange.

**Morning Surf**
Don Stone
Oil on canvas
20" × 30"

Stone often underpaints an area with a complementary color. In this case he paints a thin orange wash under areas that will later be painted in the blue range.

Many painters use this approach to take advantage of the way complementary colors vibrate next to one another.

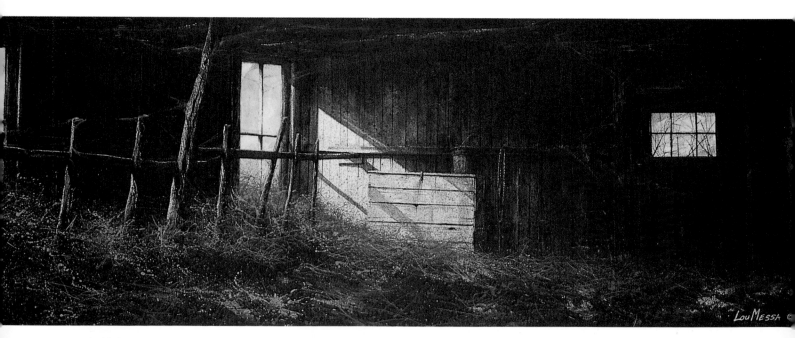

**Fond Memories**
Lou Messa
Acrylic on Crescent watercolor board
16" × 28"
Collection of Rose Novack.

Like many of Messa's paintings, this one depicts not a specific place, but a "generic" barn interior: quiet, peaceful, nostalgic. Messa begins a painting essentially as a transparent watercolor (using acrylic paint) and finishes up with both opaque and transparent passages. Very light areas are usually transparent, without the use of opaque white.

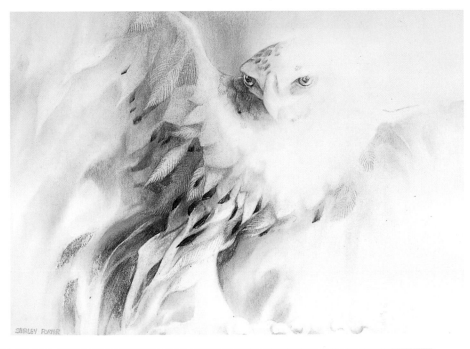

**Spectre**
Shirley Porter
Watercolor on Strathmore illustration
board
20" × 30"

Working into a very wet surface, Porter
laid in faint background color and then
painted increasingly darker areas as the
paper became less wet. Only a few small
shapes were painted on dry paper. She ob-
tained some lighter shapes by lifting paint
with a damp bristle brush; others, by neg-
ative painting (i.e., painting the space
around an object). The limited palette was
burnt umber, raw umber and Winsor blue.

**Catoctin**
Phil Metzger
Acrylic on canvas
36" × 48"

This is a secluded spot in Maryland's Ca-
toctin Mountains, where the sunlight
broke through an opening in the tree can-
opy to strike the snow-covered rocks. It
was tempting to load up the water area
with strong reflections, but to do so
would have destroyed the quiet that the
pool represents. I began this painting with
a medium-value, blue-green (Winsor blue
and Winsor green) over the entire canvas
and then worked in both value directions
from there.

John Boatright and Stephen Sebastian both use muted, almost monochromatic palettes to conjure up a restful day. In *Study in Gray* (right) Boatright uses several tools to set the tone he wants—overall low values, soft edges, restricted and muted hues, quiet texture, and the long, flat shape of the horizon. Sebastian, in *Passing Storm* (below), uses those same devices, but heightens the value on the boat and buildings to say that the sun has broken through as the clouds move away.

Restfulness doesn't necessarily call for muted colors, as Michael Brown shows in *A Chair For Rest* (page 127, top). Although he uses vibrant colors and strong value contrasts—usually a recipe for action—he still achieves a quiet mood. He lets other elements tell the story—an empty chair, simple shapes and long cast shadows. The absence of animals or human figures also helps; add some active figures and the mood might be quite different.

**Study in Gray**
John Boatright
Oil on canvas
22" × 28"
Collection of Mr. and Mrs. John Heflin II.

A limited palette (white, raw umber and cobalt blue), muted colors and values, and soft edges all help create the restful mood of a late summer day.

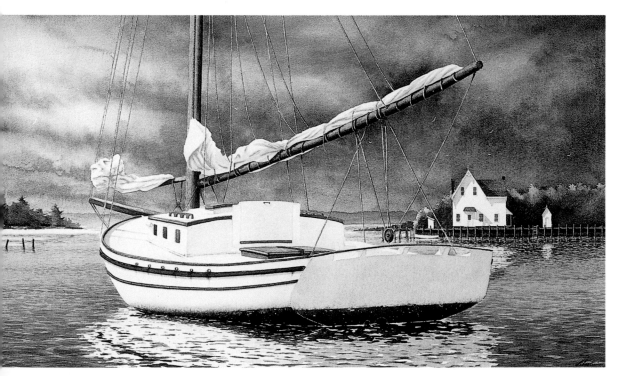

**Passing Storm**
Stephen Sebastian
Watercolor
22" × 40"

Sebastian's interest here was to emphasize the brightness of the sailboat. To accomplish this, he manufactured passing storm clouds, letting the boat and buildings catch the reappearing sunlight. The muted background and the quiet water surface combine to suggest a restful scene.

## Active Mood

To represent an upbeat or active mood, painters often abandon muted colors, placid shapes and soft edges in favor of treatments that rattle your senses. Edward Betts, in *Summerscape II* (right, bottom), chooses brilliant colors and splashy shapes that almost seem to move. The painting says "summer" without depicting any of the accepted visual symbols of the season. In a similar way, Jan Dorer's *Ice Flow*, opposite the Introduction, recalls her Alaskan experience without resorting to whales or walrus. She relies on translucent color, plenty of texture and lively shapes to tell the story.

**Active shapes, values and texture.** In *Three Koi* and *Wings* (page 129), Shirley Porter paints recognizable objects, but arranges patterns of color and value that demand you pay attention. Some teachers nag their students to establish big, important shapes in their paintings to capture attention and hold things together. In *Koi*, the large water shapes—the light blue and the blue-black areas— serve that purpose. These shapes are the foundation of the painting, and their strong value differences, along with their ragged edges, create a lively backdrop for the rest of the action. The ripples, reflections and bubbles in the water and the details of the fish all add up to a texture that enlivens the entire picture surface.

Similar action qualities show up in *Wings*. Again there are two large shapes, the blue and the white, that intersect like pieces in a jigsaw puzzle. Overlaying those shapes is a combination of vibrant color, sharp value change, and plenty of texture.

**A Chair for Rest**
Michael David Brown
Watercolor
30" × 40"

Despite the vibrant colors and stark contrasts, the mood in this painting is a quiet one. The warm cast shadows establish a peaceful mood, as does the lack of any obvious activity. Looks like siesta time to me!

**Summerscape II**
Edward Betts
Acrylic on Masonite
42" × 50"
Collection of William A. Farnsworth Library and Art Museum, Rockland, Maine.

This painting was restricted to high-key colors to project a feeling of light and warmth; light is more the subject than any specific landscape motif. The colors selected, mostly yellows and oranges, were chosen for their natural brilliance. Cadmium yellow medium is dominant, with cadmium orange and pale pinks, blues, violets and greens playing supporting roles. Color relationships or color vibrations were more important to expressing the summery image than conventional tonal or value contrasts.

## Demonstration ■ Phil Metzger
# Painting Nostalgia

Despite the large mass of darkened area, I view this painting as one having a decidedly active mood. The brilliant outdoor light, contrasted with the dark interior, is a kind of wake-up call.

**Inside Out**
Phil Metzger
Alkyd on canvas
16½″ × 12½″
Collection of Jim Halota, Rockville, MD

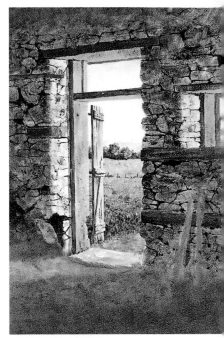

### Step 1
After tracing the drawing onto a gessoed canvas, I established the lightest, brightest part of the painting, the outdoors. All values inside the barn could then be compared to the outdoor values. Next, I smeared acrylic gesso liberally and roughly over the barn wall area to help in suggesting rough stone texture later.

### Step 2
Using thinned alkyd paint, I roughly painted the entire barn interior. Then, with a dark mixture I indicated joints between stones. Most of the interior was painted with combinations of ultramarine blue, burnt sienna, raw umber and alizarin crimson.

### Step 3
I glazed the interior with dark, transparent layers of paint thinned with Liquin, repeating this process several times until the interior values were dark enough to provide a sharp contrast with the outdoor values. Before each new glaze, I allowed the painting to dry thoroughly, a matter of about eight hours. While each glaze was wet, I painted into the wet to modify both the wall and floor areas. Most of the hay on the floor was suggested by scratching into wet paint with various sharp tools.

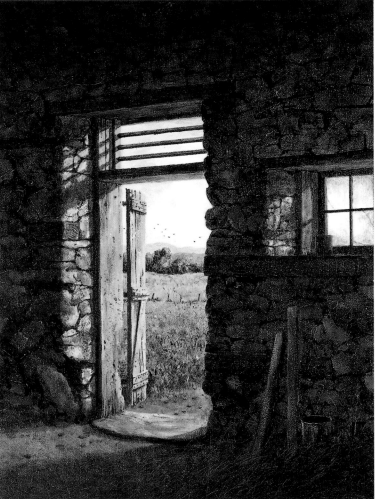

**Three Koi**
Shirley Porter
Transparent watercolor on Arches 300-lb. cold-press paper
22" × 30"

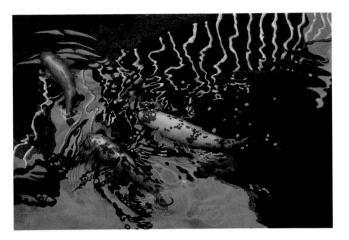

This watercolor makes good use of active, intersecting shapes, sharp value changes and texture. Porter began by painting the two large shapes on dry paper using combinations of Winsor blue, alizarin crimson and yellow ochre. Nothing was masked—she painted around the white streaks and round bubbles, softening their edges with clear water. Porter lifted the soft ripples in the light blue water areas using a stiff brush dampened with clean water. She wet the koi before painting them to keep their markings from becoming hard-edged.

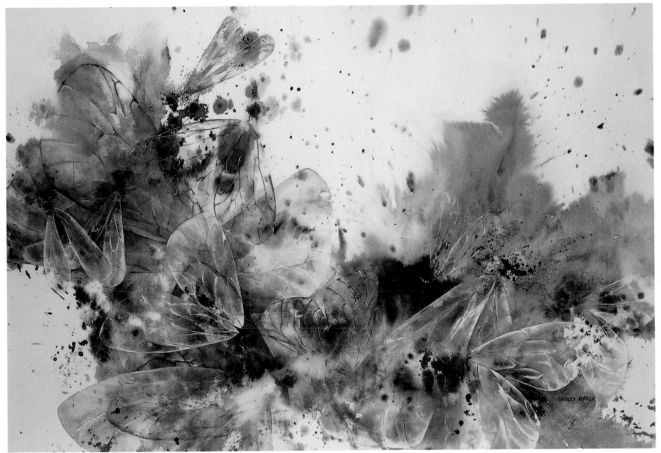

**Wings**
Shirley Porter
Transparent watercolor with opaque white highlights on Rives BFK printing paper
30" × 40"

This was a two-stage painting. Porter painted the major shapes on soaking wet paper with brilliant color (Winsor blue, Winsor green, yellow ochre, new gamboge yellow). She dropped the color into the wet surface from a loaded brush (no actual brushwork *on* the paper) and allowed it to spread. For this method, to keep paint from spreading farther than desired, you must test and control the dampness of the paper and the paint you apply to the damp surface must not be too watery. The second stage was done on dry paper, wetting only small portions where necessary to maintain soft edges. Porter painted the wings, mostly Chinese white, with small, pointed brushes.

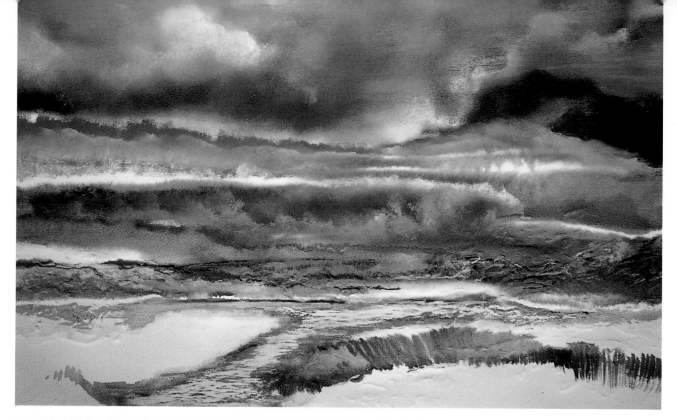

### Mood Indigo
N.F. Olson
Watercolor and pastel on Stonehenge
printing paper
30″ × 40″

Despite the dark colors in the upper two-thirds of this painting, the mood seems decidedly upbeat for two reasons: (1) a lively interplay between the warm and cool colors, and (2) well-placed value contrasts that keep the eye moving all over the picture surface. Looked at less clinically, it's a scene saved from gloominess by all that fresh, strong light breaking through the clouds. The painting is a combination of watercolor overlaid with pastel, on paper that was embossed by the artist.

### North by Northwest – Cary Grant
Alex Powers
Gouache, charcoal and pastel
29″ × 39″

Powers injects action into this painting by using many of the devices we've discussed: sharp value contrasts, irregular shapes, plenty of texture, and some sharp edges. The light on the shoulder of the near figure connects to the background and serves to tie all the figures together. A sense of distance is defined by the diminishing sizes of the figures moving into the picture space, and by the small white fence posts emerging from the ground area. The sense of action is strongly influenced by the poses of the various figures.

**The Greenhouse**
Charlene Winterle Olson
Watercolor on Stonehenge printing paper
24" × 30"

This watercolor relies on high-key values to set the mood. The splashiness of the many hues and the variety of textures all over the painting surface, along with downplayed shadows, all contribute to a decidedly cheerful scene. Olson kept the hard lines of the greenhouse from being too rigid by painting them loosely, without masking, and by keeping most values close.

# Index to Contributors

## Key to Abbreviations

| | |
|---|---|
| A.N.A. | Associate, National Academy of Arts |
| A.W.S. | American Watercolor Society |
| D.F. | Dolphin Fellowship, A.W.S. |
| F.R.S.A. | Fellow, Royal Society of Arts |
| F.W.S. | Florida Watercolor Society |
| K.W.S. | Kentucky Watercolor Society |
| N.A. | National Academy of Arts |
| N.W.S. | National Watercolor Society |
| O.P.A. | Oil Painters of America |
| P.S.A. | Pastel Society of America |
| P.S.W.C. | Pastel Society of the West Coast |
| R.M.W.S. | Rocky Mountain Watermedia Society |
| S.L.M.M. | Society of Layerists in Multi-Media |
| W.C.W.S. | West Coast Watercolor Society |
| W.H.S. | Watercolor USA Honor Society |
| W.W. | Watercolor West |

# Bibliography

Betts, Edward
*Master Class in Watercolor*
New York: Watson-Guptill Publications 1975

*Creative Landscape Painting*
New York, Watson-Guptill Publications 1978

*Creative Seascape Painting*
New York: Watson-Guptill Publications 1981

*Master Class in Water Media*
New York: Watson-Guptill Publications 1993

Birren, Faber
*History of Color in Painting*
New York: Van Nostrand Reinhold 1965

Blake, Wendon (Donald Holden)
*The Complete Acrylic Painting Book*
Cincinnati: North Light Books 1989

*The Complete Oil Painting Book*
Cincinnati: North Light Books 1989

*The Complete Watercolor Book*
Cincinnati: North Light Books 1989

*Getting Started in Drawing*
Cincinnati: North Light Books 1991

*The Artist's Guide to Using Color: A Complete Step-by-Step Guide in Watercolor, Acrylic and Oil*
Cincinnati: North Light Books 1992

Guptill, Arthur L.
*Watercolor Painting Step-by-Step*
New York: Watson-Guptill Publications 1967

Hill, Tom
*The Watercolorist's Complete Guide to Color*
Cincinnati: North Light Books 1992

Metzger, Phil
*How to Master Pencil Drawing*
Rockville, Maryland: LC Publications 1991

*Perspective Without Pain*
Cincinnati: North Light Books 1992

Pike, Joyce
*Oil Painting, A Direct Approach*
Cincinnati: North Light Books 1988

*Painting Flowers With Joyce Pike*
Cincinnati: North Light Books 1992

Powers, Alex
*Painting People in Watercolor: A Design Approach*
New York: Watson-Guptill Publications 1989

Willis, Lucy
*Light: How to See it, How to Paint it*
Cincinnati: North Light Books 1991

# Index